OIL PAINTER'S
SOLUTION BOOK
LANDSCAPES

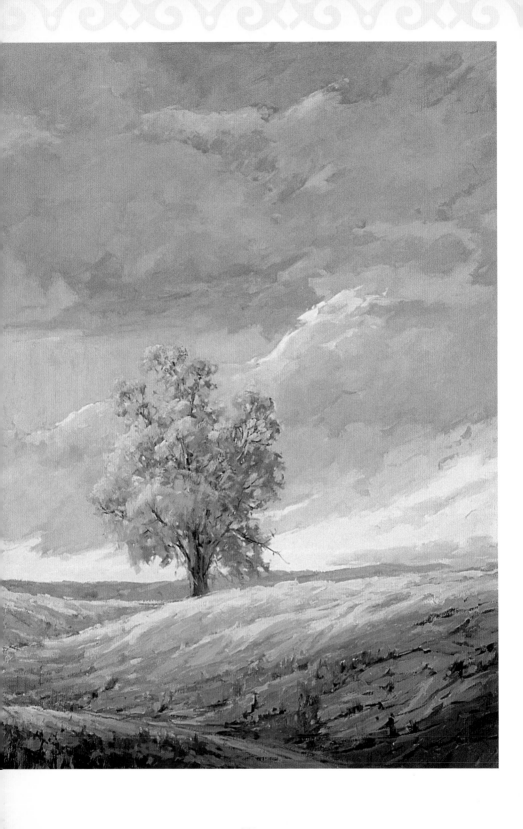

Oil Painter's SOLUTION BOOK

LANDSCAPES

Over 100 answers and landscape painting tips

Elizabeth Tolley

NORTH LIGHT BOOKS
CINCINNATI, OHIO
artistsnetwork.com

Other fine North Light Books are available from your local
bookstore, art supply store or online supplier. Visit our
website at fwmedia.com.

media

17 16 15 14 13 5 4 3 2 1

DISTRIBUTED IN CANADA BY FRASER DIRECT
100 Armstrong Avenue
Georgetown, ON, Canada L7G 5S4
Tel: (905) 877-4411

DISTRIBUTED IN THE U.K. AND EUROPE
BY F&W MEDIA INTERNATIONAL LTD
Brunel House, Forde Close, Newton Abbot, TQ12 4PU, UK
Tel: (+44) 1626 323200, Fax: (+44) 1626 323319
Email: enquiries@fwmedia.com

Distributed in Australia by Capricorn Link
P.O. Box 704, S. Windsor NSW, 2756 Australia
Tel: (02) 4560 1600; Fax: (02) 4577 5288
Email: books@capricornlink.com.au

Library of Congress has cataloged hardcover edition as follows:

Tolley, Elizabeth.
 Oil painter's solution book : landscapes / Elizabeth Tolley. -- 1st ed.
 p. cm.
 Includes index.
 ISBN-13: 978-1-58180-865-0 (concealed wire-o : alk. paper)
 ISBN-10: 1-58180-865-8 (concealed wire-o : alk. paper)
 1. Landscape painting--Technique. I. Title.
ND1342.T65 2007
751.45'436--dc22 2007001654
ISBN: 978-1-4403-2850-3 (pbk. : alk)

Consulting Editor: Greg Albert
Edited by Kelly C. Messerly
Designed by Wendy Dunning
Page layout by Jennifer Hoffman
Production coordinated by Jennifer L. Wagner

My Thanks to:

The artists who teach through books, in the
classroom or in workshops. Special thanks to
my mentors: George Gibson, NA, AWS, NWS;
Darwin Musselman, AWS, NWS; Don O'Neill,
AWS, NWS; Marian Stevens; and Irby Brown.
Each of them has been so important to helping
me become the artist I am today.

Forrest L. Doud, photographer; Brian P.
Lawler, graphic arts consultant; Penny Lentz,
graphic artist; Laylon, the Vault Gallery;
Meghan Tolley, who organized and made
sense of my notes. It was a team effort.

The editors and staff at *The Artist's
Magazine*, *Watercolor Magic* and North Light
Books for their encouragement and support,
especially Greg Albert, Sandra Carpenter and
Anne Abbott.

All of the students for their great questions
and willingness to work hard in the workshops.

Jamie Markle, Editorial Director of North
Light Books, who suggested this book, and
Kelly Messerly, who edited it with creativity and
great patience.

To my collectors who complete the circle.
And all my fellow artists who continue to
inspire me.

Special thanks to my husband, David;
daughters, Meghan and Makena, and my
parents, Audrey and Paul Handloss. Thank
you for sharing this journey with me.

Art on the cover:

Spring's Gift
Oil on linen on board
18" × 30" (46cm × 76cm)
Collection of Margaret & Keith Evans

Art from page 2

Winter Light on the Valley Oak
Oil on linen
40" × 30" (102cm × 76cm)
Collection of Ken & Helen Bornholdt

About the Author

Elizabeth "Libby" Tolley is an established landscape painter and a signature member of Oil Painters of America, the National Watercolor Society and Alla Prima International. She holds artist membership in the California Art Club and Laguna Plein Air Painters. Each year she paints for exhibitions that bring awareness to land preservation issues and at invitational plein air events. She teaches workshops outdoors as well as in the studio. Her work has been featured in many books and magazines, including *The Best of Watercolor Painting* (North Light Books), *The Best of Oil Painting* (Rockport), *The Artist's Magazine, Southwest Art, Plein Air Magazine, The Art Connoisseur, American Art Collector* and *Watercolor Magic*. She is represented by galleries on both coasts and her work is in many private and corporate collections. Visit her website at elizabethtolley.com.

Dedication

I dedicate this book to my family and mentors.

Metric Conversion Chart

To convert	to	multiply by
Inches	Centimeters	2.54
Centimeters	Inches	0.4
Feet	Centimeters	30.5
Centimeters	Feet	0.03
Yards	Meters	0.9
Meters	Yards	1.1

Table of CONTENTS

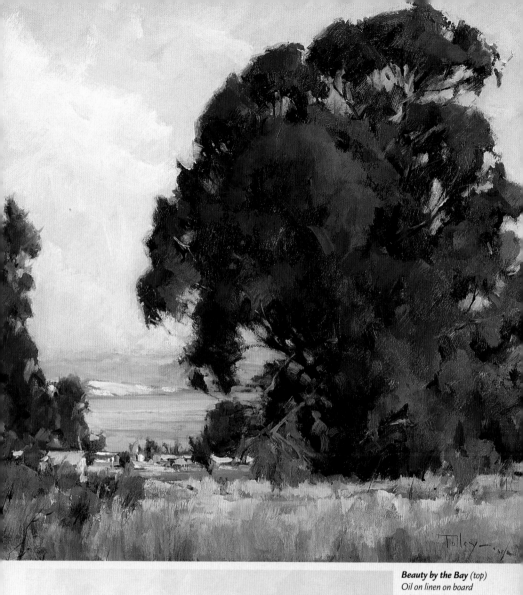

Beauty by the Bay *(top)*
Oil on linen on board
16" × 16" (41cm × 41cm)
Private collection

Morning Clearing *(below)*
Oil on linen on board
16" × 20" (41cm × 51cm)
*Collection of Mark & Elisabeth
Sarrow*

Afternoon on the San Mateo
Oil on linen on board
12" × 20" (30cm × 51cm)
Collection of Joan Irvine Smith

1

MATERIALS

As artists, we love our tools. There are many excellent materials available to us on the market. When I meet with artist friends, we often talk about new or tried-and-true materials. Someone might have found a way to keep his or her paint fresh longer, or a new light-weight Pochade box might be on the market. Often the conversation will go on to pigments, supports and other art-related materials. Materials and supplies can make for a lively lunch conversation!

The tools and materials we use can be as important to us as the skills we possess. We look for tools that will make the technical process easier and allow us to focus on the creative aspect of painting. Besides painting new subject matter, we look for different tools and materials to help us branch out and try new techniques or approaches, thus allowing us to grow as artists.

We have all heard, "You are only as good as the materials you use." This saying does have some validity. In this chapter I will present some of the materials I use and have used and describe what I have found that works.

What should I look for when
BUYING OIL PAINTS?

Not all oil paints are created the same way and not all paint manufacturers use the same pigments for their colors. Although the study of paint ingredients is fascinating in its own right, you don't need to be an expert on the chemical components of the paints you use.

Oil paints are made up of pigments, binders (vehicles), solvents, stabilizers and fillers. Manufacturers balance the formulas to make their paints intermixable and consistent in drying times and viscosity. The relative proportions of these components give each color its particular characteristics. So a paint from one manufacturer might not look or act exactly like one with the same name from another manufacturer.

If you follow the guidelines in this chapter when buying your paints, you won't go wrong. There are many good choices of readily available quality paint such as Daniel Smith, Gamblin, M. Graham,

Q What should I consider when buying paints?

A **PIGMENT** The chemical, mineral or organic material that gives the paint its color. Some pigments are made from dyes, some from the earth, including soils, and others from plants and even animals.

TRANSPARENCY Pigments differ in density and light absorption, so they can be more or less transparent, semitransparent, semiopaque or opaque. The relative transparency will affect how the paint reacts when mixed with other paints, and how it will act as a glaze.

LIGHTFASTNESS OR PERMANENCE Some paints fade when exposed to light or interact with the atmosphere, losing or changing color over time. Avoid paints that do not have a high permanency and lightfastness rating.

Holbein and Winsor & Newton. Like many things in life, you get what you pay for. Student-grade paints are cheaper because their formulas include a lot of fillers and extenders that weaken the tinting strengths; in other words, when they are mixed with white or other colors, the result is grayish. Once you have selected a brand of paint, stick with it until you become very familiar with the colors, how they mix with others, and how long they take to dry. Later, you can experiment with other brands to compare and then choose what works best for you. Finally, talk to a knowledgeable dealer or store clerk at your local art store for advice.

I list the paints I use on page 12 and their manufacturers on page 223. My list is a good place to start, but I recommend that you experiment on your own after you've painted for a while.

Q What safety precautions should I take when painting with oils?

A Many pigments are made from materials that can cause health problems if not properly handled. In other words, they are toxic if absorbed into the body through the lungs or skin. To safely work with oils you should:

- Avoid skin contact with pigments and solvents.
- Wash your hands after painting.
- Don't eat in the studio and don't put any paint or painting tools in your mouth.
- Keep your children and pets away from your paints.
- Maintain proper ventilation. If you can smell your paints or solvents, you do not have adequate ventilation.
- Never leave containers of solvents or paint mediums open when not in use.

Q What colors should I buy?

A I include a warm and cool hue for each of the three primary colors. I'll explain color temperature in more detail in chapter 4, but here's what you need to know when selecting your *palette* (range of colors). You need to have the primaries (red, blue and yellow) plus white and black.

- **YELLOW**. The cool yellow I suggest, Cadmium Yellow Light, looks closer to green than orange, while the warm yellow, Cadmium Yellow Deep, looks closer to orange than green. Yellow Ochre is another common cool, grayed yellow.

- **RED**. The cool red, Alizarin Permanent, looks more like purple than orange, while the warm red, Cadmium Red Light, looks more like orange than purple. Other common reds are Transparent Red Oxide, Cadmium Red Medium, Permanent Red, Quinacridone Red and Quinacridone Rose.

- **BLUE**. The warm blue I suggest is Ultramarine Blue, which looks closer to purple than the cool blue, Cobalt Blue, which looks closer to green than purple.

- **WHITE AND BLACK**. Ivory Black is a good color to have for making value studies (see pages 78–79) and Titanium White is a good pigment to use to lighten other colors. Another good black is Chromatic Black and Titanium-Zinc White is a popular white.

- To further expand your palette, add Transparent Earth Yellow or Transparent Yellow Oxide, Cadmium Orange and Viridian as the mixtures you can create with these pigments cannot be duplicated. Other pigments useful for landscape mixtures are Raw Sienna, Burnt Sienna and Sap Green.

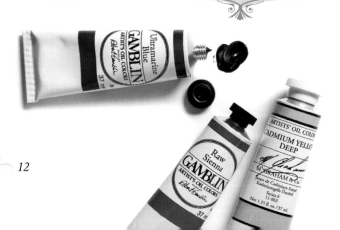

Q How do I store left-over paint?

A If, at the end of your painting session, you plan to return within the next day or two, cover the palette while it's still wet with plastic wrap. If you know you won't be back in the studio for several days or more, your paints will likely become too dry to continue using, so just scrape your palette clean and put out fresh paint at your next session.

Q Can I mix my oils with other paints?

A I do not recommend mixing oils with other mediums such as acrylic or watercolor. If you want to mix your oils with water-soluble oils, read the manufacturer's suggestions on the paint you want to mix into your oils. You should also be able to mix oils with alkyd paints as long as you check the manufacturer's label for compatibility. This will help you insure the permanence of your painting.

BASIC PALETTE

EXPANDED PALETTE

1 *Cadmium Yellow Light*
2 *Cadmium Yellow Deep*
3 *Cadmium Red Light*
4 *Alizarin Permanent*
5 *Ultramarine Blue*
6 *Cobalt Blue*

7 *Titanium White*
8 *Ivory Black*
9 *Transparent Yellow Oxide*
10 *Cadmium Orange*
11 *Viridian*

What type of PALETTE and EASEL *should I use?*

You need a flat, easy-to-clean surface to mix your colors on. This surface is called a palette. Some painters like to hold the palette in one hand while they paint, with the brush in other. Some painters like to have the palette on or next to their easel, leaving both hands free. The choice is a personal one. I prefer to set my palette in front of me whether I paint inside or out.

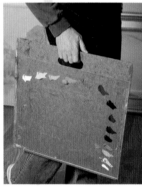

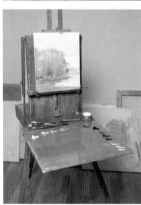

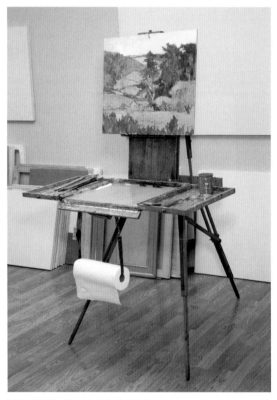

GLASS PALETTE
This palette was made with a piece of safety glass taped to a drawing board.

FRENCH EASEL AND EASELPAL
A French easel with an EaselPal works well indoors and out. Have the glass cut to fit over your mixing area.

Q What type of palette should I use in the studio?

A large glass palette on wheels is very handy in the studio. The glass surface is easy to clean and allows you to mix large puddles of color. The wheels make it easy to move around the studio. I use a large sheet of thick, nonreflective glass with a gray sheet of paper on the back. (I like to mix paint over gray so I can better judge the values.) The glass sits at a comfortable height on a small stand with wheels so I can move it around the studio easily. Inexpensive stands with built-in drawers are available from stores, art catalogs or online retailers. The extra storage is handy in the studio.

Cover your wet paint with plastic wrap to keep it fresh for the next day. If you're not coming back to the studio for awhile, clean the palette by simply scraping it with a glass scraper.

If you are setting up your first studio and plan to work on location as well, a good easel and palette combination would be a French-style (portable) easel and an EaselPal, which is an extension that holds the palette off to the side. While not as lightweight as some other setups, this combination works well and enables you to paint on a range of canvas sizes.

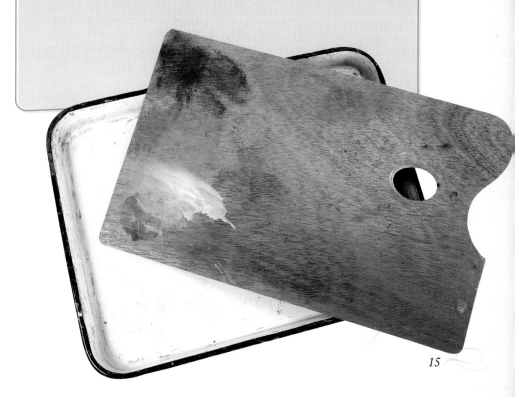

Q What palette do I need for working on location outdoors?

A Working outdoors is more difficult than working indoors because you have to deal with the environment. Changing lighting conditions, heat, cold, wind, onlookers, size limitations and portability are all factors that make working on location a greater challenge compared to working in the studio.

There are several good choices for a suitable outdoor palette. A white enamel butcher's tray has been a used by outdoor painters for many years. Because the white surface is hard on the eyes and it can be heavy, many artists find using acrylic or glass taped to a piece of gator foam a better solution.

Paper palettes are also difficult to use on location because they're lightweight, easily blown over and the white surface reflects light into your eyes.

Traditional, hand-held wooden palettes with a thumb hole also work well, and often are sized to fit into the lid of the French easel. They do require extra care (the paint shouldn't be allowed to dry on a wooden palette) and the brown color makes judging colors a bit harder.

Even though a glass palette can be a challenge to work with outside, I still prefer it to other palettes. You can minimize breakage by putting clear contact paper underneath the palette so it will hold together if it breaks. Whatever you choose, make sure the palette is secure on your easel or the wind may blow it over!

PLEIN AIR PREPARATION
Pack a bag filled with *plein air* painting supplies ahead of time and you'll be ready to go when the right mood—or weather—stikes.

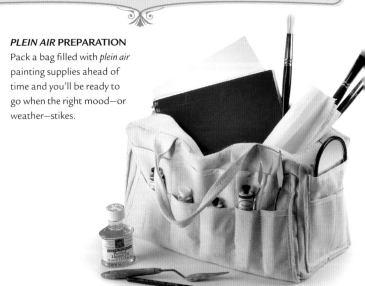

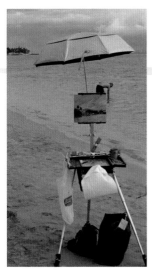
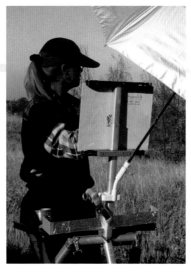

OUTDOOR EASEL WITH BUILT IN PALETTE

Being well prepared with a stable easel, secure palette and other essential tools nearby when painting on location will ensure a more productive day.

Q What should I include in my bag for painting on location?

A The things I like to keep in my bag are:

- Brushes kept in a tube from a paper towel roll
- Palette knife for mixing paint
- Paint scraper and rubbing alcohol to clean the palette
- Small sketchbook and vine charcoal
- Alkyd medium in a tube, and a medium cup with a lid
- Bungee cords and large clips to hold things down
- Compact umbrella that attaches to the easel
- Sunscreen
- Warm fingerless gloves
- Bug repellent
- Drinking water

What type of BRUSHES do I need?

Brushes are made with both natural and synthetic hairs, or *filaments*. Either synthetic or natural filaments are suitable for oil painting. Natural bristles have a springiness that makes them nice to paint with. Synthetic filaments are a bit less springy but can withstand stronger cleaners. Filaments are bound together with a *ferrule*, a metal collar. Brushes come in different shapes and sizes. The most common types of brushes are *flats*, *rounds*, *filberts*, *brights* and *scripts*. Most oil painters prefer brushes with longer handles in order to use a light, loose touch with thick paint on a vertical surface. However, shorter handles are useful if you're storing your brushes in a smaller paint box when traveling to outdoor painting sites.

BRIGHT BRUSHES

Shorter than flats, with the width and length about equal, brights are used for short, controlled strokes with thicker paints. Brights tend to make square brushstrokes that can be monotonous if you're not careful.

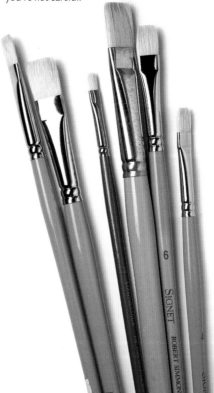

ROUND BRUSHES

Rounds have rounded, pointed tips that make them good for thinner lines and long strokes with thinner paint. Use rounds to create the finer details in your paintings.

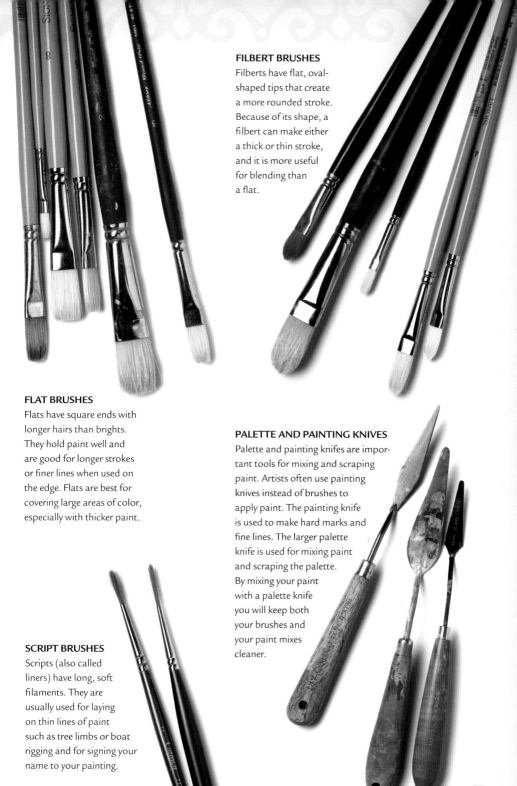

FILBERT BRUSHES

Filberts have flat, oval-shaped tips that create a more rounded stroke. Because of its shape, a filbert can make either a thick or thin stroke, and it is more useful for blending than a flat.

FLAT BRUSHES

Flats have square ends with longer hairs than brights. They hold paint well and are good for longer strokes or finer lines when used on the edge. Flats are best for covering large areas of color, especially with thicker paint.

PALETTE AND PAINTING KNIVES

Palette and painting knifes are important tools for mixing and scraping paint. Artists often use painting knives instead of brushes to apply paint. The painting knife is used to make hard marks and fine lines. The larger palette knife is used for mixing paint and scraping the palette. By mixing your paint with a palette knife you will keep both your brushes and your paint mixes cleaner.

SCRIPT BRUSHES

Scripts (also called liners) have long, soft filaments. They are usually used for laying on thin lines of paint such as tree limbs or boat rigging and for signing your name to your painting.

19

How should I care for
MY BRUSHES?

Good brushes are critical to good painting. Purchase good brushes, take proper care of them and they will last a long time. Good brushes are one of the most important investments a painter can make. Cheap brushes produce poor results and can be frustrating when loose hairs get onto your painting. Owning a few good brushes that receive the proper care is better than going through many student-grade brushes.

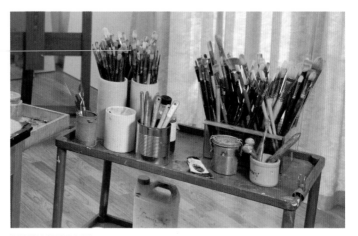

BRUSH STORAGE

Q How should I store my brushes while I'm painting?

A I am right-handed and keep my clean brushes in canisters and jars on a table to my right so I can easily grab a clean brush. I also keep my clean brushes on my right side when I'm working at my French easel or Pochades. I lay my dirty brushes on the left side of my easel. Some artists make trays with holes so they can stand their dirty brushes up while they work.

Q How should I wash my brushes?

A After a painting session, wipe the excess paint from your brushes on paper towels and dispose of them outside the studio building (paint rags and paper towels should really be placed in an air-tight metal container to avoid the risk of spontaneous combustion or the buildup of fumes). Then rinse the brushes in a small quantity of odorless mineral spirits or in vegetable oil to remove as much of the remaining paint as possible. The vegetable oil will maintain the natural springiness of animal-bristle brushes and is easier on the environment. Finally, wash the brushes with mild dish soap and warm—not hot—water. You can also buy brush cleaner made for this purpose at a good art supply store. Wear protective gloves while washing your brushes to keep the paint, mediums or solvents from getting into your skin. Squeeze or towel out excess water, reshape the tip of the brush and lay it down flat to dry so water won't run into the ferrule, weakening the glue that holds the bristles in place. Store dry brushes in a can or container handle down. Don't store the brushes with anything that might press or misshape the bristles.

HOW SHOULD I CARRY MY BRUSHES?
If you are traveling or painting on location, transport your brushes is in a brush wallet. A paper towel roll works for just carrying them out to the field.

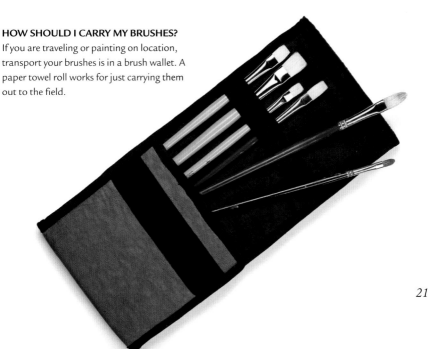

What SOLVENTS
do I need?

Solvents are used for cleaning purposes, while mediums are used to thin the paint for painting. Turpentine and mineral spirits are the traditional solvents of oil painters, but because they are very toxic and have strong fumes, less noxious solvents, such as odorless mineral spirits, have taken their place. Another advantage of OMS is that in addition to its usefulness as a cleaner, it can be mixed with mediums to thin paint.

Be very careful when using mineral spirits. Just because you can't smell OMS doesn't mean it's completely safe. OMS deserves to be handled with care because it is toxic, flammable and hazardous to the environment. Call your recycling center for disposal instructions. Do not wash art materials down the drain.

SOLVENTS
Use only artist-grade solvents.

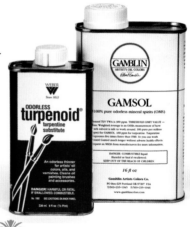

Q **How should I store solvents?**

A All solvents are potentially flammable, so they should always be stored away from heat in an airtight container.

Q How do I use mineral spirits?

A You must have good ventilation in your studio when using any kind of mineral spirits. While mineral spirits are less toxic and flammable than turpentine, they are still dangerous if used incorrectly. Reading the product label for safety precautions is essential. If you're using OMS to thin paint, mix it with an alkyd base medium; using OMS alone to thin paint will weaken the paint film. You can also thin your painting medium with OMS if the medium does not contain damar varnish.

Q How do I use turpentine?

A Use turpentine only as a medium, never as a cleaner. Use only refined artist turpentine (do not use the stuff you can buy at hardware stores). Make sure you have adequate ventilation and keep the container closed when not in use.

Mineral Spirits and Damar Varnish Don't Mix

If you use a medium with a damar varnish base, you must use turpentine to thin your medium. If you add mineral spirits (even if they're odorless) to damar varnish, the resin will drop out of the solution and cloud the medium. If you see commercially prepared damar varnish or damar/turpentine medium that is cloudy, select another brand. Even if you use turpentine as your painting medium, use OMS for brush and studio cleanup.

What MEDIUMS
do I need?

Mediums are used to thin oil paints or speed up or slow down their drying. A good all-purpose medium is an alkyd-based medium because alkyd is a synthetic compound (as opposed to an organic compound such as linseed oil) that dries uniformly and usually within twenty-four hours. I have found the new alkyds work well and eliminate the need for turpentine in my studio. There are a number of alkyd mediums on the market. I use Galkyd, a well-known, readily available product. Check the label to make sure the medium you are choosing can be thinned with your solvent.

MEDIUMS
There are many types of mediums on the market. Experiment to see which ones work best for you.

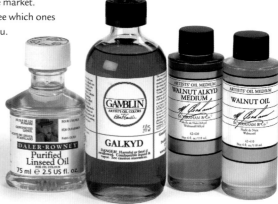

Q How do I use a retouch varnish?

A If you are going to work on a painting after the first application of paint has dried, re-wet the painting with the medium you have been using so the subsequent layer will adhere.

If you have been using a three-part medium of turpentine, damar varnish and linseed oil, use a retouch varnish with damar varnish in it. However, if you are using an alkyd, you need to use alkyd and OMS. I use a thin mixture of 1 part alkyd to 1 part OMS.

Q How do I use mediums to thin my paint?

A To thin your paint with mediums, follow this process:

1. Put the medium you need for the day in a medium-sized cup or jar that's airtight when closed. Small glass jars or metal cans are good. Certain plastics are acceptable as long as the solvent doesn't melt them. Never use Styrofoam.

2. To start with a thin wash of color and medium, dilute with 1 part alkyd medium to 2 parts OMS. Thin the paint so it resembles the consistency of milk. If it's too thin, add more medium and paint.

3. For the next layers of paint, add increasing amounts of medium and less OMS. The old rule "fat over lean" still applies, meaning the bottom layers of paint should include less oil (alkyd or linseed) than the upper layers. Oily paint dries more slowly than paint with more OMS. If the upper layer dries before the lower, the paint film is more likely to crack over time.

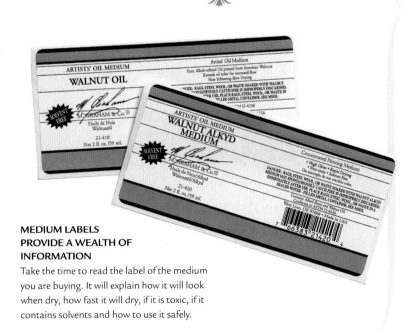

MEDIUM LABELS PROVIDE A WEALTH OF INFORMATION

Take the time to read the label of the medium you are buying. It will explain how it will look when dry, how fast it will dry, if it is toxic, if it contains solvents and how to use it safely.

What SURFACE should
I PAINT ON?

The surface you choose to work on affects how the paint behaves and looks, so your surface makes a great deal of difference to the finished piece. Whatever you choose to paint on, make sure it is prepared to take oil paint. The surface should be primed with either acrylic gesso ground or oil ground. You can apply acrylic gesso directly to the canvas. You will have to apply an additional ground, or sizing, before applying an oil ground.

Q Why paint on fabric?

A Linen and cotton canvases have long been the favorite supports of oil painters. They can be stretched on stretcher bars or glued to a board. They can also be bought prestretched and primed, although they are more expensive this way. Stretched linen and cotton canvas are popular surfaces to paint on because they are light and relatively portable. Many painters like the flexible "give" of a stretched canvas. The springy surface responds to the pressure the artist applies to the brush when applying the paint, unlike a solid, unresponsive board.

The disadvantage of working on fabric is its impermanence. Stretched fabric is delicate and can be easily damaged. Stretched canvas can shrink or sag, depending on the humidity, eventually causing damage to the paint film. Raw canvas eventually will rot from contact with oil; the surface must be properly sized or gessoed.

Start with a medium-textured cotton or linen for a landscape surface. Use a medium- to fine-textured cotton or linen canvas for smaller paintings and canvas with a more pronounced texture for large paintings.

There are canvases made from synthetic fibers such as nylon, fiberglass and polyester that are stronger and more resistant to climatic conditions than natural canvases. Synthetic canvas is a good choice for locales with high humidity or extreme temperatures. For greater permanence, you also can glue the canvas to a rigid surface (see page 31).

Q Why paint on gessoed Masonite?

A Some artists prefer painting on gessoed Masonite panels because they are generally inexpensive compared to canvas mounted on boards and you can create a variety of surface textures on them. Only untempered Masonite (hardboard) should be used for painting. Tempered Masonite has resin baked into it that prevents the gesso from adhering properly.

GESSOED SURAFCES
Using acrylic gesso is a fast and easy way to prepare your surfaces for oil paint.

Q Which ground should I use?

A Acrylic gesso is the most popular ground because it is nontoxic, easy to apply, inexpensive, flexible and permanent. Simply brush acrylic gesso onto your stretched canvas with a housepainting brush. You can use the gesso straight or slightly dilute it with water. Once the first coat is dry, sand some of the texture down. You can apply as many coats as you like, sanding between each, although one or two coats is usually enough.

The traditional way to prep a canvas for an oil-based primer or ground is to apply a thin layer of warm glue sizing made from rabbit skin. Once this is dry, apply an oil-based primer and let it dry for a long period of time. This method is smelly, messy and time-consuming, making acrylic gesso the preferred ground for most painters. There are also many fine commercially prepared linen and cotton canvases that have been primed with either acrylic or oil.

How Do I Prime a Board for Painting?

Many artists prefer to paint on gessoed boards rather than linen or cotton canvas. Making your own is easy and you can make them as textured as you want. Choose quality hardwood without cracks. Rinse your brush out as soon as you finish priming to keep the gesso from drying in the bristles.

MATERIALS

SURFACE
Any hardwood such as Masonite that's free of cracks

BRUSHES
Housepainting brush

OTHER
Acrylic gesso, apron, clean water for cleaning the brush, lint-free rag or disposable towels, rubber gloves (optional)

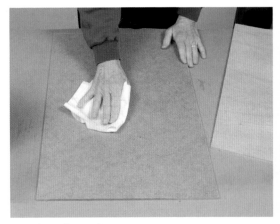

1 **Clean the Surface**
With a slightly damp, lint-free rag, wipe the surface of the board to remove any sawdust or dirt.

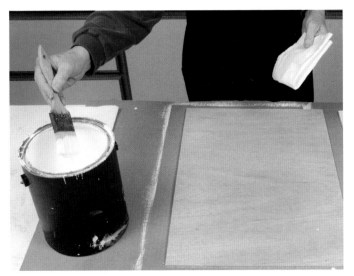

2 **Protect Your Work Surface**
Make sure that you have protection for your table, because you will be covering the top and sides of your board with gesso. Mix the gesso thoroughly before applying it to the board.

3 Apply the Gesso

Apply the first coat, covering the board and sides completely. Let this dry, then sand. Apply another two layers, sanding after each. Once the top and sides of the board are dry, add a layer of gesso to the back of the board to prevent warping.

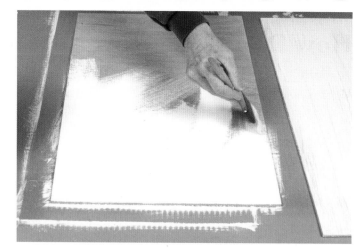

4 Sand the Final Layer

To create a board with a smooth finish, lightly sand the final layer with fine or medium-fine sandpaper. If you want your surface to have more texture, this is not a necessary step.

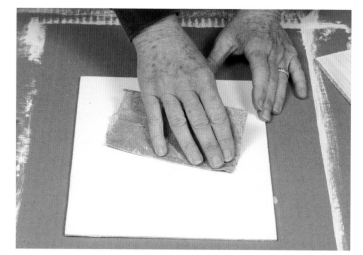

5 Add More Layers of Gesso (Optional)

For more texture, use a stiff brush when applying the gesso, letting the brush marks show.

Try preparing your boards with different finishes to see what you prefer.

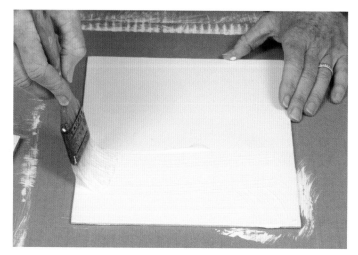

How Do I Make Canvas Panels?

Making your own canvas panels is not hard. It's a great activity to do in the evening if you prefer to paint in the daylight. By morning, the boards will be ready to be trimmed and used. Be sure you use an archival, acid-free glue such as Miracle Muck that is designed to adhere fabric to wood.

MATERIALS

SURFACE

Any hardwood panel such as Masonite that's free of cracks

Precut primed cotton or linen canvas that is ½ inch to 1 inch (12mm to 25mm) larger than the board

OTHER

Acid-free archival glue, books or other heavy objects, glass sheet (as least as large as your wood panel), lint-free rags, rolling pin, rubber brayer, sharp utility knife

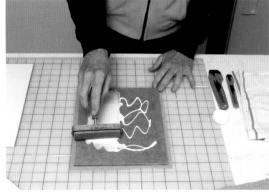

1 Apply the Glue

Wipe the board clean of any particles with a lint-free rag. Lay the canvas on your cutting surface, primed side down, then lay the board on top of the canvas. Drizzle acid-free glue onto the board, and roll out the glue with a rubber brayer. Cover the board entirely with glue, but it does not need to be thick.

2 Flip the Board

Turn the board over onto the back of the canvas. Don't worry if some of the glue drips onto your canvas.

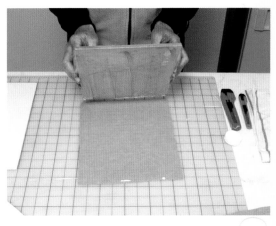

3 Align the Weave With the Board

Make sure the weave of the canvas is parallel to the edges of the panel. Press down firmly.

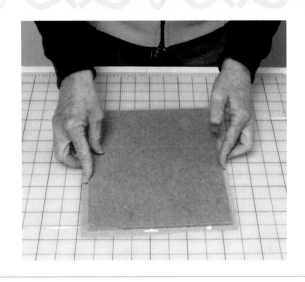

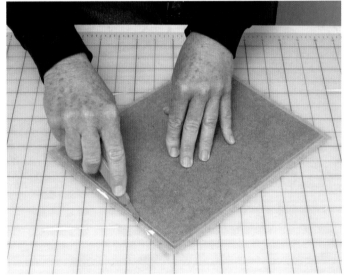

5 Trim Excess Canvas and Dry

Trim the canvas to ⅛-inch (3mm) around the board to allow for a bit of shrinkage as the fabric and glue dry. Place the canvas panel under a piece of glass with books on top of it. The weight helps the fabric to dry smoothly. Let this dry for about twenty-four hours.

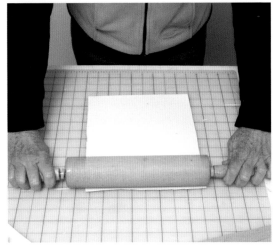

4 Remove Air Bubbles
Flip the canvas-covered panel over so that the canvas is facing you. Roll out the air bubbles with a rolling pin.

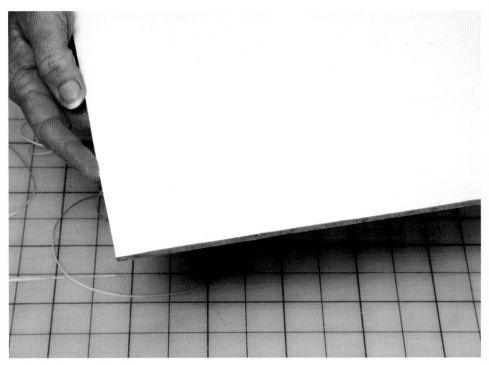

6 Trim Excess a Final Time
The next day trim the excess canvas off with a sharp utility knife. Your panel is ready to be painted on.

What REFERENCE MATERIAL *do I need?*

It is very important that you use your own photos and sketches for reference material. Unless noted, all photos in magazines are copyrighted, and the artist whose work is copied has the legal right to sue if the image is used without approval. You should use your own reference material for other reasons, too: First, the creative process begins with the selection of subject matter. Seek out what is attractive to you; do not rely on others to make this choice. Second, you should train yourself to be sensitive to what "moves" you in a scene. First-hand observation will train your eye, sharpen your artistic sensibilities and increase your store of knowledge about the world. So learn to create your own reference material right from the start.

Sketches are the best reference material because the sketching process allows you to focus on what attracted you to the subject in the first place. A sketch is like a rehearsal for the final painting, allowing you to work out problems before committing paint to the canvas. However, a good photograph will eliminate the pressure to capture every detail and will remind you of your initial impression, so it's often helpful to use both a reference photo and a sketch.

Q How should I store reference materials?

A Whatever system you use, make sure it's easy for you to find the right materials. Store photographs in a binder that is labeled and filled with like photos and slides. You might also use a card file.

Many artists now use their computers to store digital reference photos. Back up your digital photographs on discs and put similar images on the same discs for easy reference.

Store color sketches and studies in a clear plastic bag to protect them from damage. Later, when you want to test a color, you can paint on top of the clear bag.

Q What materials should I sketch with?

A You can sketch in a sketchbook with pen or pencil, or on a painting surface with charcoal or paint. I often sketch with charcoal on my canvas before committing to paint since I can easily wipe off charcoal with a lint-free cloth if I change my mind.

SET UP YOUR SKETCH NEXT TO YOUR PAINTING

I used the small, framed painting for color notes for the larger painting. Placing the two next to each other made it easier to compare the colors. Another idea is to put the sketch into a clear plastic bag and test the color on the protective covering.

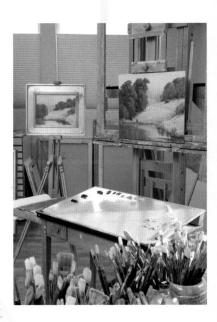

REFERENCE MATERIAL

Always use your own sketches and photographs for reference material.

35

What OTHER SUPPLIES
do I need?

In addition to brushes, paints and surfaces, here are other supplies that will make painting more enjoyable.

- **Paper towels and lint-free rags.** Use these for cleaning surfaces and wiping brushes.

- **Plastic or metal cups and lids.** Use these for storing mediums.

- **Solvent can with a tight-fitting lid for solvent.** Use a metal can for solvents; glass and plastic containers are not recommended.

- **Denatured alcohol**. For cleaning glass palettes.

- **Hand-held mirror.** Using a mirror to see your painting in reverse will give you a new perspective of your work and help you spot problems. A mirror can also increase the viewing distance, allowing you to take a step back without walking across the room.

- **A large table or chest of drawers.** You can put your glass palette on this and have plenty of room for other materials.

- **Space for your work to dry.** A wet painting lying on a horizontal surface is a painting waiting to be smeared. Pin your finished pieces on a wall with long tacks while they dry, or prop them up along a wall, away from foot traffic.

THE EXTRAS THAT MAKE PAINTING EASY
Having additional items like paper towels, a mirror and a plastic cup to store your medium can make your time in the studio more productive.

❊ **Varnish.** Once an oil painting is thoroughly dry (after six months or more), apply a final protective varnish (such as Gamvar, an alkyd-based varnish) with a wide, soft brush that you use just for that purpose. Follow the manufacturer's suggestions for the best atmospheric conditions to apply the varnish. Problems such as *blooming* (a white haze on top of the varnish) can happen when there is too much moisture in the air. Apply the varnish in a thin layer with slightly overlapping parallel strokes. Ideally, the varnish should be removed with a varnish remover and reapplied after a period of ten years or more.

DRYING WALL
While my paintings are hanging up to dry, I can look at them in the mirror across from them to check their reverse images.

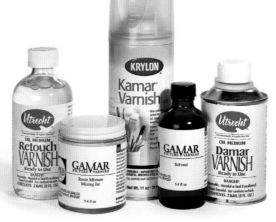

VARNISH
Applying a coat of varnish to your finished painting once its thoroughly dry will protect it from dirt and damage.

What do I need to PAINT INSIDE?

Ideally, you need a space that you can dedicate to your painting. You need a space that allows you to work uninterrupted by family, friends and distractions. A good studio should support your creative energy and allow you to concentrate on your painting. A spare room is the best, as long as it has adequate light and ventilation. The room should be at least 10' × 10' (3m × 3m).

Your easel is the centerpiece of your studio. It should be well lit, with even lighting over your canvas. The lighting should eliminate sharp dark shadows of your hand when applying paint. If natural lighting is available, the easel should be positioned so the light comes from behind and perhaps off to one side.

Alongside the easel should be a suitable support for your palette and containers of medium, and a table for your paint, brushes, knives and other equipment needed close at hand.

If possible, your studio should be convenient to a suitable sink to wash your hands and brushes. Bathroom and kitchen sinks are not appropriate.

Avoid visual clutter in your studio. Too many distractions for your eye will impair your ability to concentrate.

Q How do I get good ventilation?

A Ventilation when painting with oils is an absolute must. All solvent containers should be kept closed as much as possible while working, and securely closed after painting. Opening windows or doors is an easy solution. You can also purchase reverse fans that fit into open windows to pull fumes out of your studio and the rest of the building. If you do not have good ventilation in your studio, avoid using solvents there. Also avoid placing solvents where a fan might pull the fumes across your face.

Q How do I get even light in my studio?

A The light you paint in should be consistent. Natural light coming from the north (called north light) is the most desirable. Windows facing north allow the most consistent light to pass through. Windows facing south offer inconsistent light. If you don't have a source of natural north light, you can purchase lamps that simulate north light. These are generally referred to as *color-balanced lights*. Place the lights off to either side and slightly above your brush and hand so you don't cast a shadow onto your work.

Visit a lighting professional to ensure you're getting even lighting in your studio. Bring a plan of your room, including the placement of your easel, for an informed discussion of lighting possibilities.

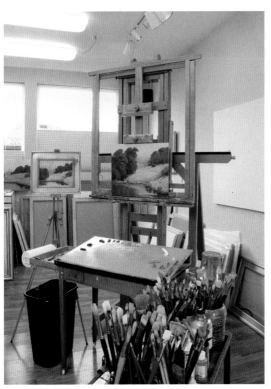

MY STUDIO
My studio has enough room for me to move around the easel and a large glass-topped palette made from an old sewing table. Light comes from the north-facing windows, with additional daylight-balanced bulbs. I also have windows facing on the east and south sides of the room that I can open for cross ventilation.

How do I
SET UP OUTSIDE?

Being comfortable on location is essential in being able to focus on your subject matter and apply paint. Having a simple setup makes going outside more enjoyable. Have a backpack designated for outdoor use that is packed and ready to go at all times, so you can immediately go out when the light is right.

Keep a checklist in or on your portable easel so you can quickly determine if you have all you need when you are packing or walking to location. Getting all set up to paint the perfect view only to discover that your palette is back in your studio is very frustrating.

Q **What materials do I need to paint outside?**

A So you do not lose valuable painting time, try to take only what you need so that you can make one trip to set up your supplies. You will need an outdoor easel and palette, a bag to carry your supplies to the location and a way to transport your wet painting home. An umbrella to shade you and your painting is a great addition to your outdoor painting supply kit. You might also consider sunscreen and bug repellent.

A *Pochade box* is a small paint box and easel combined into one portable unit. The lid is designed to hold a small canvas panel. A small palette is built into the box itself.

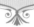

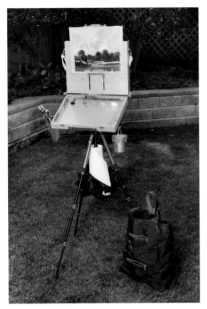

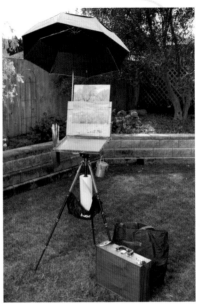

OUTDOOR EASEL SETUP
Some of the most popular Pochade boxes are the Versa by EASyL (shown above) and those made by OpenBoxM (shown at right). They conveniently transport your wet paintings and travel well.

OUTDOOR EASEL WITH UMBRELLA
Using an umbrella designed to attach to a tripod or easel is handy to use and keeps the sun off the painting palette. Umbrellas that can collapse small make transporting them in your backpack easier.

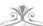

Q What lighting conditions should I consider?

A Attach an umbrella to your easel so that your painting is shaded, even if it is an overcast day. If it is too windy to use an umbrella, make sure your painting is not in the sun; otherwise it will be hard to judge the color and value relationships.

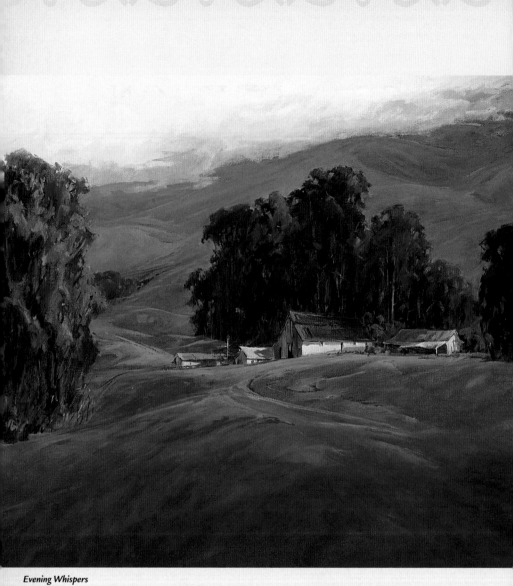

Evening Whispers
Oil on canvas
30" × 36" (76cm × 91cm)
Collection of Mark & Elisabeth Sarrow

2

COMPOSITION
& DESIGN

Painting is a visual act. How we set the stage is important in the
success of getting our message across to the viewer.

Landscape painters will be presented with light and color we might
never have imagined. We will also be presented with scenes that on
their own are beautiful to look at, but to be a strong painting, will need
rearranging to create a convincing, strong statement. We use our skills
as artists to convey powerful messages. Once we know what we want to
say, we can begin to translate these thoughts onto the canvas. The way
we design our compositions will help viewers understand the ideas we
are trying to express.

What is COMPOSITION?

Composition is the way pictorial elements are arranged to form a picture. Composition is how an artwork is "put together" in a *format* (the overall shape of a painting: square or rectangular, vertical or horizontal). A composition's *design* is the way individual parts of an artwork are arranged. Artists use the elements and principles of design to establish the *center of interest* (or focal point), the area the artists wants viewers to focus on.

Although there is no definitive list of design elements to which every artist would agree, the elements are usually listed as *line, direction, color, texture, shape* and *tonal value*. These are the "raw materials" of a composition.

The principles of design are the rules by which these raw materials are transformed into an effective composition. Again, there is no one list to which every artist would agree, but the principles of composition usually include *unity, contrast, dominance, repetition, alternation, gradation, balance* and *harmony*. The elements and principles of design are discussed in detail in this chapter.

 How do I recognize composition problems?

Looking at your painting in reverse with a hand-held mirror is very helpful in spotting problem areas. Place a mirror on the wall behind you in your studio so you can turn and see your painting in reverse as you work. You can also put a note on your easel to remind yourself what elements of design or what thought or mood you want to keep in mind as you are working.

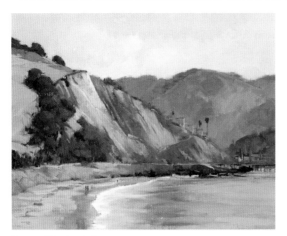

PROBLEMATIC COMPOSITION

Here the viewer's eye moves along the water and down the hill, then quickly exits the painting down the mountain's diagonal. The line and shape of the foreground hill overpowers the composition, and although the background hill and sky are interesting, they don't hold the viewer's eye in the painting.

Summer Morning, Avila
Oil on linen on board, 16" × 20" (41cm × 51cm), Collection of the artist

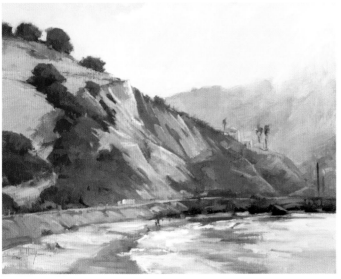

EFFECTIVE COMPOSITION

In this painting, the viewer's eye moves along the water and up into the hillside. Vertical elements such as the trees slow the diagonal movement of the viewer's eye. This composition leads the eye around the painting, rather than out of the picture.

Morning Clearing, Avila
Oil on linen on board, 11" × 14" (28cm × 36cm), Collection of William Hosner

What are the ELEMENTS OF DESIGN?

You might think of these elements of design as the visual tools you use to create a work of art. As you read through the elements of design, you may notice that it's almost impossible to describe one element without another element or principle of design coming into play. The interrelatedness of these elements and principles is proof of how naturally they work together.

✳ **Line.** Lines can be straight or curved, thick or thin, in a group or by themselves. The edge of a shape can function as a line in

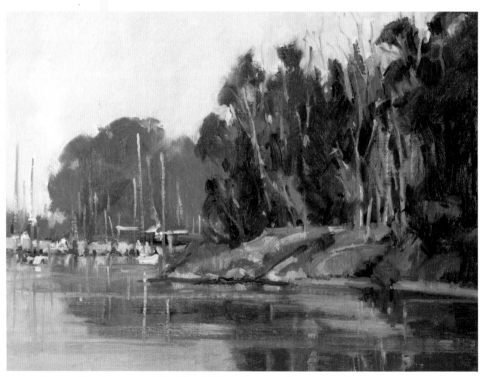

Summer Morning, Windy Cove
Oil on linen on board
9" × 12" (23cm × 30cm)
Collection of Carl Pangia

LINE, DIRECTION, TONAL VALUE AND COLOR
Here the straight lines and geometric shapes of the boats play against the organic shapes of the trees, land and water. The vertical masts and trees lead the eye upward, but the strong, irregular boundary between the trees and the sky keeps the eye from continuing out of the painting. Subtle gradations of tonal values appear in the water, with more value contrast between the light sky and the darker trees. Cool greens dominate the composition, with areas of warmer light and some muted reds to add variety.

a painting, guiding the eye in a similar fashion. Whatever their appearance, use lines to guide the viewer's eye into and around your painting to the center of interest.

* **Direction.** Direction is the way the viewer's eye moves within the painting. There are four possible directions: horizontal, vertical, circular and diagonal. Only one of these directions should be dominant in a composition; the others should be subordinate so they won't compete.

* **Shape.** Landscape painters tend to use irregular, organic shapes instead of perfect geometric shapes. The shapes in a picture should vary in size, one or two larger shapes with some medium and smaller shapes. If the shapes are too similar in size, the picture will be less interesting. The shapes should also vary in complexity, with some simple and others more complex for variety. See page 54 to learn how to make interesting shapes.

* **Tonal Value.** Tonal value is the relative lightness or darkness of the shapes in a painting. Using a variety of tonal values in a full range from very dark to very light make your paintings more interesting. Your focal point should contain the greatest level of value contrast—your lightest light next to your darkest dark—to draw the eye toward it.

* **Color.** Colors can be cool or warm, bright or muted. Cool colors such as green and blue suggest things that are cool like water, ice, and vegetation. Warm colors suggest things that are hot such as fire, sunlight, and hot metal. Either warm or cool colors should predominate. Equal amounts of cool and warm colors are visually boring. Use your brightest, most intense colors for the focal point.

* **Texture.** Texture refers to the tactile quality suggested by the way the paint is applied in a picture. Textures can be rough, smooth, even or irregular. There should be a variety of textures in a landscape painting, but one type should be dominant.

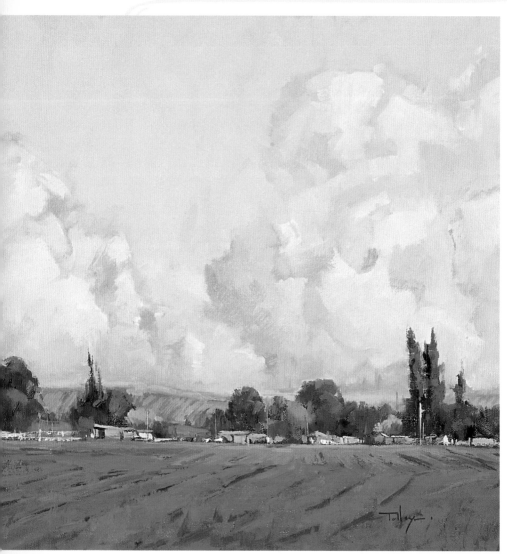

Winter Afternoon, Paso Robles
Oil on linen on board
16" × 16" (41cm × 41cm)
Collection of Alan Acosta & Tom Gratz

SIZE AND SHAPE

The large, curvilinear line of the clouds contrast against the strong horizontal where the field meets the buildings. The curvilinear shape is echoed by the rounded shapes of the trees, bushes and plowed field, while the vertical lines of the trees and poles provide contrast to these rounded shapes. The variety of shapes and direction work together creating a harmonious composition.

What are the PRINCIPLES OF DESIGN?

The goal of composition is to create a picture that attracts and retains the viewer's attention. The principles of design are the ways artists implement the elements of design.

* **Unity**. Every part of a picture should relate to all the others. The elements of the picture should form a unified, coherent whole that "hangs together." The way the elements are rendered should be consistent throughout.

* **Contrast**. Contrast (or *conflict* or *opposition*) results from obvious differences between aspects of the elements in a picture. Light and dark, bright and dull, smooth and rough all describe types of contrasts. Too little contrast is boring, but too much obvious contrast can overwhelm a composition.

* **Dominance**. Sameness is boring, so where there are contrasting pairs of pictorial elements, one element should be dominant. Allowing one element to dominate will help you achieve unity while providing contrast.

* **Balance**. There are two types of balance: *static* and *dynamic*. Static balance, also called *symmetrical balance*, occurs when similar elements are placed on either side of a composition. Dynamic or *asymmetrical balance* may be achieved by placing unlike forms that have equal visual "weight" on either side. For example, balance a large dark area on one side of a canvas with several brightly colored objects on the other side.

* **Harmony**. Harmony results when there is an interesting variety of elements in a picture that are balanced in a unified whole whereby each part of the composition works to express the idea behind the overall composition.

* **Repetition**. Repeating elements throughout a composition contribute to the unity of the piece.

* **Alternation**. Contrasting pairs of pictorial elements can alternate in a picture to maximize visual interest. For example, an alternating pattern of lights and dark, such black-white-black-white, can create interesting contrast.

* **Gradation**. The gradual and progressive change from one color or value to another. This could be the color and value change as you move across the sky towards the sun. The values should become lighter and the colors should become warmer.

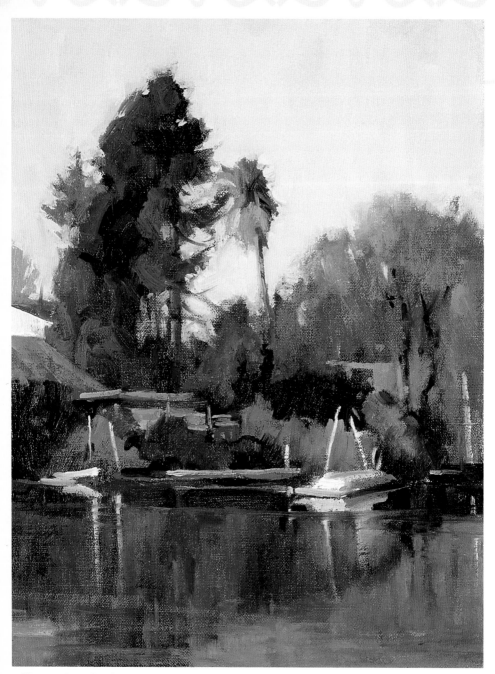

Brilliant Morning on the Lake
Oil on linen on board
12 " × 9 " (30cm × 23cm)
Private collection

UNITY, CONTRAST AND BALANCE

In this painting, the vertical format supports the vertical lines of the trees and poles. The dominant green and blue-green color scheme provides unity, while the complementary color adds a nice contrast. The white boat on the right creates a good dynamic balance with the visual weight of the darker forms on the left side of the painting.

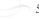

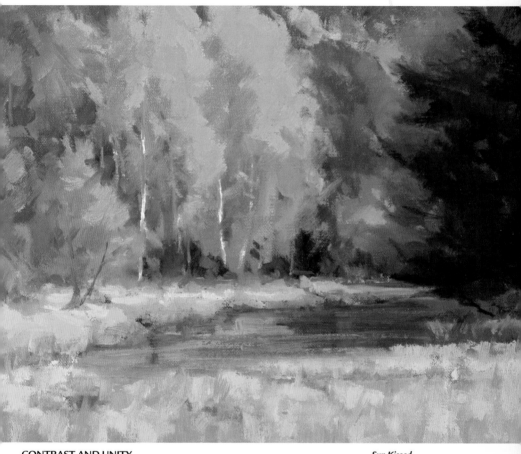

CONTRAST AND UNITY

Here similar shapes and colors repeat to unify the composition. The texture of the smooth water contrasts with the dark fir tree. The horizontal of the water provides contrast to the vertical direction of the trees and grasses.

Sun Kissed
Oil on linen on board
9" × 12" (23cm × 30cm)
Private collection

How do I determine
WHAT TO INCLUDE?

Once you have determined what part of a landscape interests you most, keep your focus—both visual and mental—on what attracted you to that subject in the first place. Your painting should "be about" one thing, making one and only one "statement." Perhaps it's the way the shapes and colors of the trees pull your eye into the scene, or perhaps it's the dramatic pattern of shadows and sunlight. Include elements that will enhance your subject, and leave out anything that will detract from the statement you want to convey.

Q How can I get better at editing my compositions?

A Making several sketches and paintings of the same subject or landscape is great practice. The more you depict the same scene, the more you will discover about its character. You can experiment with different points of view, different areas of emphasis, and different selections of details until you discover the most powerful combination.

Start by sketching the same scene several times, altering the composition each time. Eliminate an object or emphasize another, noticing how this changes the painting's impact. You will quickly see how to improve your paintings by selecting and simplifying key elements.

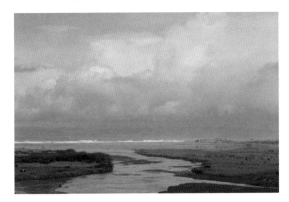

COMBINE REFERENCE PHOTOS TO GET THE COMPOSITION YOU WANT

The more you work with your design the more you will be able to find creative solutions. The clouds in the top photo at left were too horizontal to create the movement that would enhance the meeting of the river and ocean, so I used the cloud formation from the bottom photo. By trying different formats and using different reference materials, you can explore options and come up with a satisfying composition.

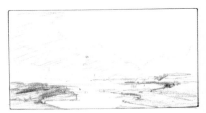

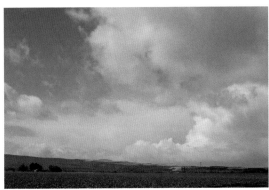

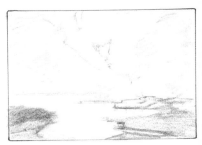

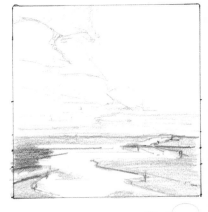

SKETCHES FROM PHOTOS

In the sketches at right, the top design has nice movement within the long horizontal rectangle. The middle sketch seems more ordinary, although the line direction takes the eye to the sunlit land. The larger format of the bottom one allows more room to repeat the curvilinear shape of the land in the sky. The land forms in the top sketch will be good with the cloud forms in the bottom sketch. Together they will provide good shapes and good direction for an interesting painting.

What is an INTERESTING SHAPE?

An interesting shape has no two dimensions the same and has concavities and convexities ("innies and outies"). Shapes with similar sides and angles such as squares, regular triangles and circles are boring shapes. Symmetrical shapes are less interesting than asymmetrical shapes. Several shapes of the same size are less interesting than shapes that vary in size.

Pay particular attention to the silhouettes of the shapes in your picture. The silhouette should immediately identify what the shape

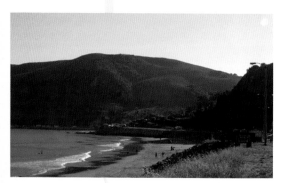

USE REFERENCE PHOTOS TO RECORD INTERESTING SHAPES
This is a beautiful scene, especially when the afternoon light comes down the back hill and illuminates the old trailer park against the trees. On the other hand, the photograph is not very exciting because the space divisions are pretty much the same size and the shapes are static. The basic forms are simple and strong, however, so with some creative alternation, this scene can become a dynamic composition.

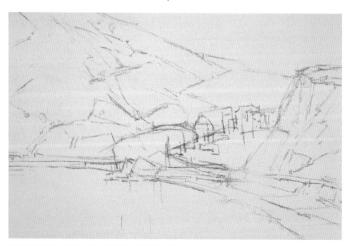

SKETCH TO DETERMINE THE BASIC SHAPES
Break the scene into dynamic abstract shapes. Learning to see and work with abstract shapes will help you create strong abstract compositions to provide solid foundations for your paintings. Don't worry about details at this point.

is. This outside shape is much more important to the composition than the details within.

Look at the shapes in your painting as an abstract pattern rather than as representations of things. A good painting should be based on an interesting pattern of interesting shapes, regardless of what the shapes are supposed to be. Your painting should read like an abstract painting in the beginning; then, as you continue to paint, it may become more and more representational.

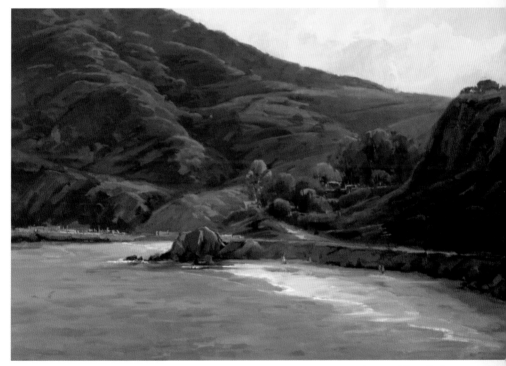

COMMIT THE DESIGN TO PAINT

I eliminated most of the sky so the mountain becomes more powerful. In the reference photo, the water and land divided the composition about in half, so I needed one shape to be dominant. To achieve this, I emphasized the hill by making it larger. The horizontal rocks that jut into the water stabilize the composition, while the vertical trees slow the diagonal action of the mountain.

Summer Light, Avila Cove
Oil on linen on board
20" × 30" (51cm × 76cm)
Collection of the artist

Action lines are the directional lines of the painting that indicate movement. They may conflict with each other or they may echo each other. Establish action lines early in the design process to indicate how the viewer's eyes should move throughout the painting.

The action lines in your painting should direct the viewer's attention around the picture. You don't want any lines that stop the viewer's eye from moving or lead it out of the picture. Follow these guidelines for creating effective action lines.

* Avoid lines that point directly to the corners of a painting—especially the lower corners. The viewer's attention will go right out of the painting like water down a drain.

PLANNING ACTION LINES

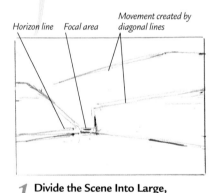

Horizon line Focal area Movement created by diagonal lines

1 Divide the Scene Into Large, Abstract Shapes
Break up the canvas with large abstract shapes. Direct major lines toward the center of interest.

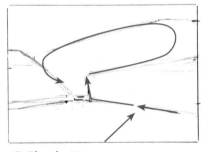

2 Plan the Movement
Put some marks on your sketch to indicate how you want the viewer's eye to move through the painting.

- Avoid placing important elements in the exact center of the picture. There is no movement in the center; remember that the axle is the part of the wheel that rotates the least.

- Vary the spacing of your elements so the distance between them doesn't look artificial. Avoid placing objects equidistantly.

- Avoid lines that direct the viewer out of the picture.

Once you have become comfortable with design, however, try breaking the rules. This will help you find out what works and what doesn't—and why. Use a sketchbook for thumbnail drawings to help you become more familiar with your subject and to work on the design of your painting. Sketches help you visualize your painting and work out problems before you get to your canvas.

Jagged edge slows movement of diagonal and interlocks the mountains to the shape of the sky

Vertical and horizontal lines stabilize the diagonal lines

Adding tonal value and detail to the sky creates additional movement

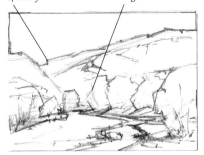
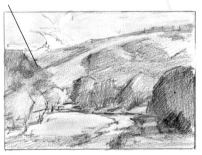

3 Define the Subject Matter From the Abstract
Carve the scene from the abstract shapes you created. Use the creek to move the viewer into the painting and up into the hills toward the sky shape.

4 Lay In the Values
With the addition of the values, the sky shape now has movement as well. The viewer can return to the painting.

How do I DIVIDE SPACE *in my painting?*

Divide the space unequally giving dominance to one of the divisions. Unequal divisions make the larger space dominant.

* Avoid placing the horizon in the exact middle of your landscape.

* Avoid dividing your picture in half vertically; for example, don't place a tree trunk or telephone pole right in the middle.

* Avoid lines that go diagonally from corner to corner. This divides the composition into two equal parts and directs the viewer's attention right out of the picture.

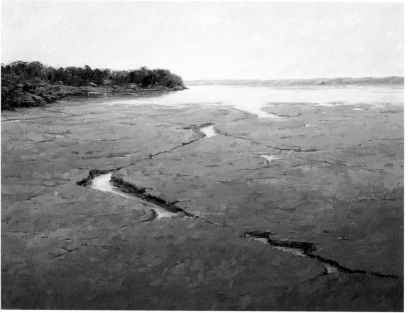

Embraced by the Light
Oil on linen on board
36" × 48" (91cm × 122cm)
Collection of Pete &
Jeanne Vander Poel

A HIGH HORIZON LINE EMPHASIZES THE LAND
Here, the land is definitely the dominant area because it is so much larger than the sky area in the painting. The water in the marsh forms an action line that directs the viewer into the painting.

Q How do I use the horizon line to divide space?

A The placement of the horizon line determines whether the painting will be primarily about the land or the sky. Are you planning to paint a large foreground? Then you will need a high horizon. If you want to concentrate on the background hills or the sky, then you will need a low horizon.

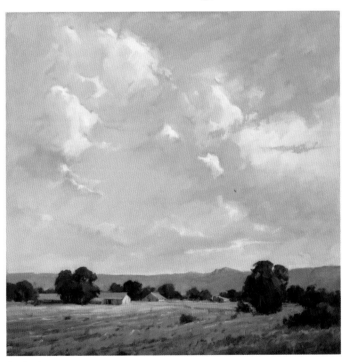

A LOW HORIZON LINE CREATES A LARGE SKY
In this painting the large sky area gives the painting a feeling of expansiveness. The viewer's eye is drawn to the larger barn in light because of the action lines and contrast.

Passing By
Oil on linen on board, 24" × 24" (61cm × 61cm), Collection of Jeff & Sara Colodny

How do I create a center of interest or FOCAL POINT?

Every painting needs a center of interest, or focal point. Consider what you want the painting to communicate to the viewer: the subject or concept that will engage the viewer's mind. Subjects in landscape paintings that tend to engage viewers include:

* Figures

* Animals

* Structures such as buildings or vehicles

Next, consider how you can attract the viewer's attention toward the subject you want to emphasize. These characteristics will help you create a center of interest to draw the viewer's eye:

* Stark contrast, especially very dark against very light

* Bright, saturated color (see page 87)

* Hard edges (see page 122)

* Straight lines or regular forms

* Small details

* Repeating patterns

Be sure that your focal point supports the main idea you want to convey so your composition remains in harmonious balance. For example, buildings in a landscape can attract the viewer's eye if they are the focal point. This is a good place to use stronger color and contrast. However, if the buildings are there only to support the idea, for instance to show scale, they need to be less commanding in contrast and in color (see page 63 for an example).

Avoid creating a busy pattern or sharp value contrast in a part of your painting that is not the center of attention. All elements should work together in harmony to focus the viewer's eye and mind.

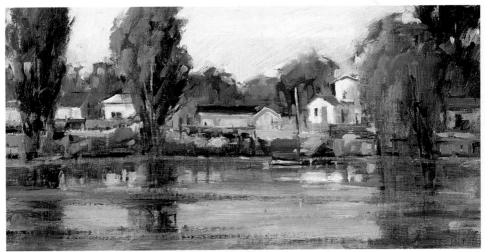

COLOR ATTRACTS THE EYE

In this summer painting the dominant color is green. The red provides contrast to the greens and helps draw the viewer's eye to the focal area of the white houses and their reflections.

Summer Morning on the Lake
Oil on linen on board
8" × 16" (20cm × 41cm)
Private collection

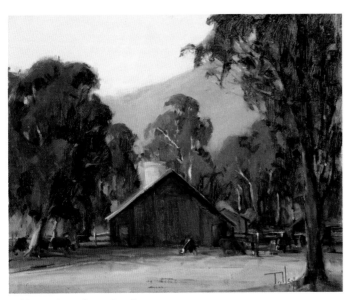

CREATING A CENTER OF INTEREST

The viewer's eye is first attracted to the cattle and the barn, which lead the viewer's eye toward the focal point of the trees in light. The barn, the cattle and the trees all function together to create a center of interest.

Golden Evening on the San Geranimo
Oil on linen on board, 10" × 12" (25cm × 30cm), Collection of the artist

Where should I place the
CENTER OF INTEREST?

The center of interest should be located at a point that is not in the exact center of the picture, not too close to any corner, and not equidistant from either the top and bottom or the right and left borders. A good way to determine such a point is to divide your picture into three sections, both vertically and horizontally, much like a tic-tac-toe board. The four intersections are points that fit the requirements.

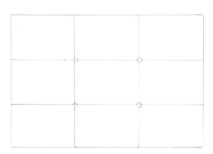

USE A GRID TO DETERMINE THE FOCAL POINT

Many landscape artists place their focal points in the areas circled. To find these points divide your canvas in thirds both horizontally and vertically.

BALANCING THE CENTER OF INTEREST WITH THE SECONDARY CENTER OF INTEREST

Here the center of interest (the houses along the bluff) is the area where the most color and activity takes place; however, the eye can move away and through out the painting. The rocks on the left help balance the composition. The horizontal of the far bluff help stabilizes the painting. Using strong directional lines keeps the viewer's eye moving back to the houses on the bluff. The figures are kept simple and create a secondary center of interest.

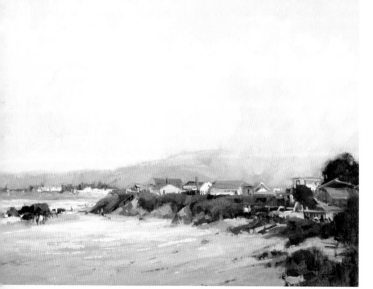

Morning Clearing Cayucos
Oil on linen on board, 16" × 20" (41cm × 51cm), Collection of Mark & Elisabeth Sarrow

Any of these four locations are good places for locating your center of interest. There should be only one main center of interest. There may be others in your picture, but they must be clearly secondary. Two equally attractive focal points divide and weaken the viewer's attention.

If you do have a secondary center of interest, make that area subordinate to the main focal point by using less contrast, less intense colors, fewer details, soft edges and little or no patterning. In other words, use less of each device that make the primary center of interest a powerful "magnet for the eye."

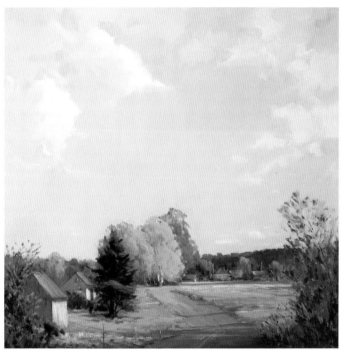

LEAD THE VIEWER'S EYE
The focal area is in the lower third of the composition. In order to keep the eye moving through the painting, repeated colors and shapes are used. The sky is an expansive area of clouds filled with subtle lines that return the eye to the focal area.

Morning Glow
Oil on linen
24" × 24" (61cm × 61cm)
Collection of Vartan & Nora Milian

How do I select the BEST FORMAT *for my painting?*

As a landscape painter, you have many ways to show your personal vision and convey your message. One of the ways you can do this is by choosing an effective format for your painting.

Templates that correspond to the proportions of your canvases offer a quick, easy way to see how the subject matter would look in different format presentations. Outline the templates in your sketchbook to establish a frame for your composition. Doing a thumbnail sketch inside this frame will let you see which format will look best for the finished painting.

Another way to explore different formats is to use small canvases for your studies. Not only can you design with these small canvases, you can experiment with your paint and practice your brushwork.

Use Small Canvases for Location Studies

Small canvases that work well on location or for small studies are: 9" × 12" (23cm × 30cm), 10" x 12" (25cm × 30cm) and 12" × 12" (30cm × 30cm). For a long horizontal or a tall vertical format that is really dramatic, try an 8" × 16" (20cm × 41cm) canvas.

FORMAT TEMPLATES
These tools can help you explore a variety of formats. Use these templates to create borders for thumbnail sketches in your sketchbooks.

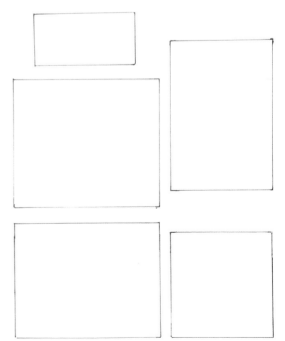

The most common canvas sizes for landscape painting have proportions that are 2 × 3, 3 × 4, 4 × 5 or 5 × 6. Prestretched canvases available in art stores generally come in sizes 8" × 10" (20cm × 25cm), 10" × 12" (25cm × 30cm), 11" × 14" (28cm × 36cm), 16" × 20" (41cm × 51cm) and 16" × 24" (41cm × 61cm). Usually landscape paintings are oriented so the horizontal dimension is the longest. Orienting the format so the vertical dimension is the longest (known as a portrait format) can be a dramatic and interesting departure from the traditional landscape format.

While the horizontal canvas is a more lyrical presentation and the vertical more formal, the square format offers a contained, massive quality to the painting. The four equal sides make square formats a challenge; however, with thought you can design a great composition within this format.

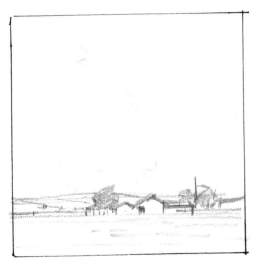

ADD BORDERS TO YOUR SKETCHES
Without a border, there is no format. You can see that without a border, the drawing is just floating on the paper. Trace your templates or use a ruler to put small formats in your sketchbook.

Gallery of
FORMATS

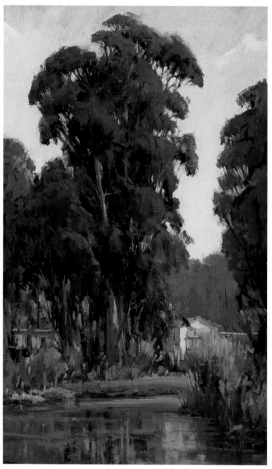

An Elegant Morning
Oil on linen on board
20" × 12" (51cm × 30cm)
Collection of William & Susan Grove

VERTICAL FORMAT

I used the vertical format to paint a "portrait" of these trees and to reinforce their vertical shape. I extended this shape with the reflections in the foreground pond. The clear reflections also enhance the quiet mood of the scene.

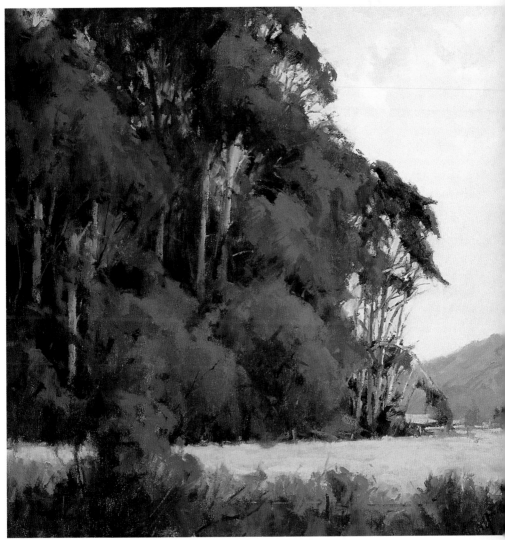

SQUARE FORMAT

I used a square format to emphasize the massiveness of the eucalyptus grove, while maintaining the vertical, elegant nature of the trees.

One Fine Day
Oil on linen over board
20" × 20" (51cm × 51cm)
Collection of Burt & Becky Adams

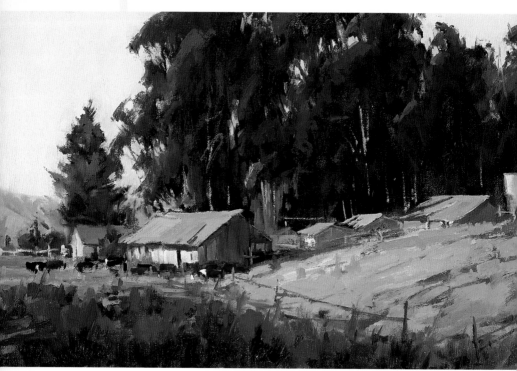

Dinner on the Bar Nothing
Oil on linen on board
12" × 20" (30cm × 51cm)
Private collection

LONG HORIZONTAL FORMAT
I placed the buildings in the bottom third of the painting to create more room for the tall trees while leaving plenty of room for the eye to move back into the painting.

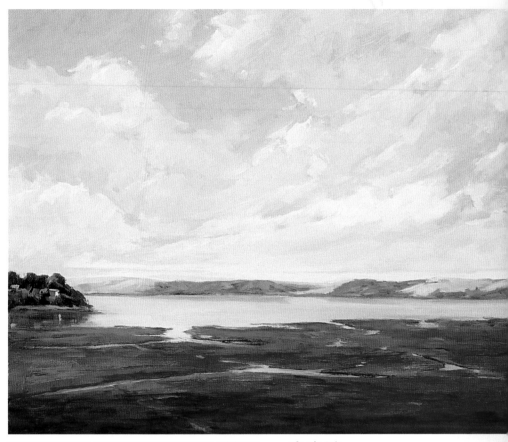

STANDARD OR "LANDSCAPE" HORIZONTAL FORMAT
The feeling of this painting is airy and light, with clouds that seem to float away. Because of the height and width of the canvas, there is enough space for the viewer's eye to easily move both horizontally and vertically through the composition.

After the Rain
Oil on linen on board
24" × 30" (61cm × 76cm)
Collection of William & Elaine Bateman

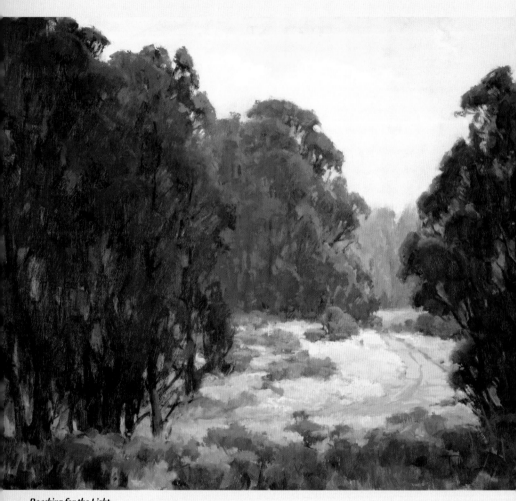

Reaching for the Light
Oil on linen on board
16" × 20" (41cm × 51cm)
Collection of Stephen & Patti Overturf

3

TONAL VALUE

I remember driving home one afternoon many years ago. I was headed west and looking at a large grove of trees. They were almost in backlight. I found myself saying, "I think the light on the trees is a value 4." I saw the trees as a mass of value rather than color. This was such a breakthrough for me! To understand and use the artist's language, and to see through the artist's eye, was a memorable moment.

When I am on location, I try to determine the values of my main shapes. I compare and look for the parts of the scene that are the lightest and darkest. I look for which value range I see most. I squint slightly to help me see relationships between values. Later, in the studio, I can apply the knowledge I gained from observing the scene in natural light and noticing how it affected the values.

In order to become fluent in the artist's language so we can convey what we see and feel, we must learn to understand values and how they relate to each other to describe light. Once you grasp these concepts, you will be able to create value patterns with variety as well as unity in your compositions.

What is
TONAL VALUE?

Tonal value is the relative lightness or darkness of a color. The range of possible values may be best described through a gray scale from black to white. Black is the darkest possible tonal value; white is the lightest. The gray scale is usually numbered with black as value 1 and white as value 10. Between these two is an infinite range of grays.

As you will learn in chapter four, value is one of the characteristics of color. All colors appear as a range of grays in a black-and-white photograph, so all colors can be compared to a gray scale to determine their relative tonal values. Some colors such as pure yellow (yellow right out of the tube) are light in value. Others such as pure blue (blue right out of the tube) are darker in value.

Only part of the range of values on the value scale should dominate a painting. Either more light values or more dark values should be predominant so the composition will look more unified. If a painting

Value Is Relative

Values are more easily read than color or texture. The value of an object relates to what is around it. If black, value 1, is next to gray, value 3, there is not a big jump; however, put black next to value 8 and the contrast is greater, creating more intensity. A good rule of thumb is to keep your major value changes at or near the focal point.

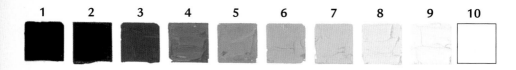

1 2 3 4 5 6 7 8 9 10

VALUE SCALE

Make your own value scale which will give you a useful tool for judging values and give you practice mixing them. There are two ways to make your scale. You can take a 3" × 10" (8cm × 25cm) piece of thick, gessoed cardboard and divide it into nine or ten 1" × 3" (3cm × 8cm) compartments and paint each an increasing darker value from white to solid black. Or you can take nine or ten 1" × 3" (3cm × 8cm) pieces of gessoed cardboard and paint each one a different value from white through black and the assemble the strips into a ten-step scale.

has predominantly lighter values, it is said to be in a *high key*; if the darker values dominate, it is said to be in a *low key*.

Although either light, medium or dark values should dominate a painting, not all paintings will contain a full range of values. A high-key painting should still have some dark or medium values

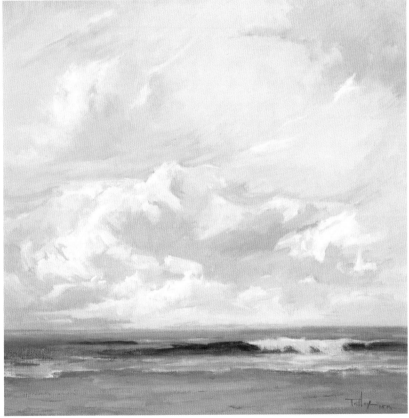

HIGH-KEY VALUE SCHEME
This high-key value scheme has large light masses and small dark masses. The darkest values are in the upright waves, which are in shadow. The majority of the values are in the range of 5 through 10.

Between Showers (First Day Out)
Oil on linen on board
20" × 20" (51cm × 51cm)
Collection of Steven Luczo

and a low-key painting should have a few light or medium values. These contrasts enliven the painting and draw the eye toward the center of interest.

The lights and darks in your painting serve several other functions. Value contrasts create excitement and also help viewers distinguish one object from another. Values give form to objects. The lights and darks reveal how the forms are arranged in space. Light and dark values indicate the direction of light by showing what is in light and what is in shadow. Values changes can produce textural effects by describing the surface qualities of the objects in a picture.

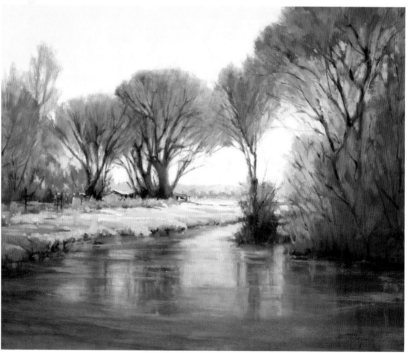

Winter's Gift, Tucson
Oil on linen on board
20" × 24" (51cm × 61cm)
Private collection

MIDDLE-KEY VALUE SCHEME
Landscape paintings often have a large area of middle-key values that tend toward the light side, such as in this example. The dark accents in the trunks, in the areas along the riverbank and in the structures add a nice contrast. The light is cool and the shadows are warm, and the complementary colors of grayed blues and oranges enliven a quiet subject.

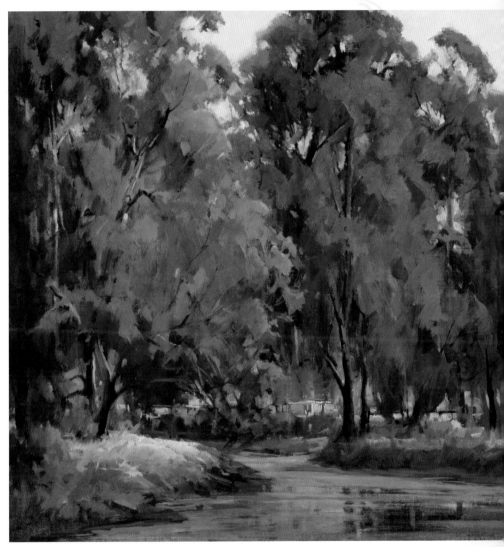

LOW-KEY VALUE SCHEME
Here I used lower-key and middle-key values. The light values are subordinate to the dark, and yet they are very important to the success of the painting because they draw the viewer back into and around the composition. In this painting the light is warm and the shadows are cool.

Evening's Last Glow, Santa Cruz
Oil on linen on board
20" × 20" (51cm × 51cm)
Collection of the artist

How should I use VALUE in my LANDSCAPES?

Generally, a landscape can be divided into four value planes: the sky, the ground, the slanted planes and the vertical planes. These value planes are influenced by how much light hits them from the sun. In a landscape, the sky is the lightest plane because it is the source of light; the flat ground is the next lightest because light can easily hit its flat surface. Slanted planes receive some light from the sun, while the vertical planes are not easily hit with full light and thus receive the least amount of light. Of course, these guidelines are just that and can change depending on where the sun is in the sky.

An object's tonal value is affected by the way light hits it. Predominantly dark areas will have some lighter patches as light hits surrounding surfaces and bounces into the dark values. Do not play up the value contrast here. It is best not to paint these bounced lights too light, or the attention will be drawn into the shadow where the light is in the dark and the value shape will be broken up.

Remember to include a range of values in your painting, but allow one key to dominate.

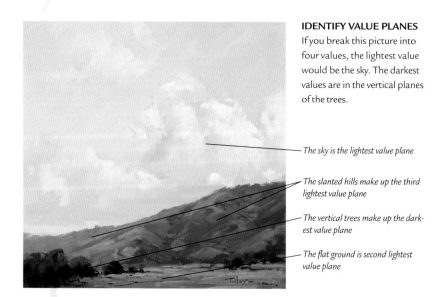

IDENTIFY VALUE PLANES
If you break this picture into four values, the lightest value would be the sky. The darkest values are in the vertical planes of the trees.

The sky is the lightest value plane

The slanted hills make up the third lightest value plane

The vertical trees make up the darkest value plane

The flat ground is second lightest value plane

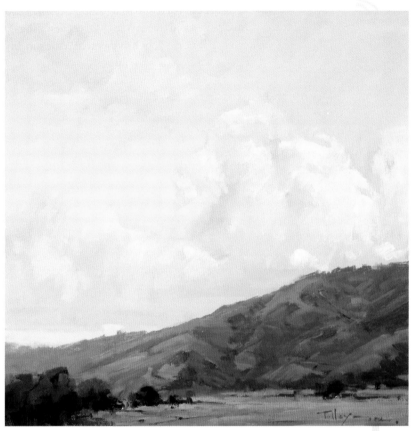

SEEING VALUE PLANES IN COLOR

Notice how lively the painting looks when you see it in color. The values describe the light direction and the colors convey the feel of the cool, wet, winter day.

Winter Into Spring
Oil on linen on board
12" × 12" (30cm × 30cm)
Private collection

Artist Solution

Do you have a painting that is not working? Take a piece of clear plastic wrap and lay it over your dry painting. Paint the corresponding values in black, gray and white on top of the plastic. Lay the painted wrap on a white board and see how your values look. Do you have a strong value pattern? Are your value changes readable? Often you can solve your problem by looking at your work in gray tones.

How can I
EFFECTIVELY USE VALUE?

Seeing a landscape as a pattern of tonal values is an important skill for an artist to cultivate. Study the scenes around you and look for the darks, the lights and the midtones. You can also study good black-and-white photos and analyze how the lights and darks work to make them interesting.

Making black-and-white studies is excellent practice for painting (and drawing for that matter). You can work from life on location or from color photos. Make a sketch, reducing your subject into a few large shapes. Each shape should be a closed shape, similar to a puzzle piece. Then label these shapes W for white, LG for light gray, MG for mid gray, DG for dark gray and B for black. Finish by painting each shape with paint of the appropriate value. You will have to simplify and exaggerate the value differences you see.

Look at your study and determine which value range is dominant. Are the shapes too similar in size? Is there sufficient tonal contrast between the shapes? Is the contrast at the edges of adjacent shapes strong enough to distinguish them from one another? Do the values need to be softened where light breaks the form?

A light shape surrounded by a darker value will look lighter than a shape of the same value surrounded by middle value. A dark shape will look darker if surrounded by a lighter value. This visual phenomenon is known as *simultaneous contrast* and can be used to distinguish forms and to create eye appeal in a painting.

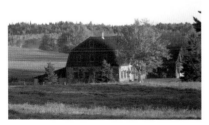

REFERENCE PHOTO

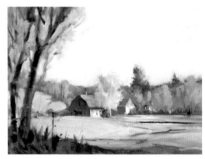

VALUE PAINTING

Q Why do a value sketch?

A This will help you quickly determine if you have a dominant value pattern. Simply create a black-and-white sketch of your intended composition. Use a pencil or pen to block in all the shadows in black, leave all the lights in white then block in the middle values.

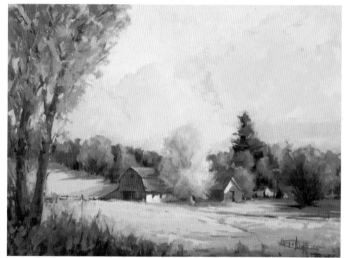

Morning on the Island
Oil on linen on board, 12 " × 16 " (30cm × 41cm), Collection of the artist

COMPLETED PAINTING
Making value studies can also help you step away from the color in front of you and use a different color palette. Just make sure you follow the value pattern in your study.

Q Why do a value painting?

A Make a value painting before you begin to paint in color. Once you've identified the dark and light areas, add the middle values. This will help you see light and dark value planes and give you an opportunity to practice your paint application and brush-strokes.

How Do I Create a Value Painting?

A small color study I painted on location seemed a good candidate to take to a large painting in the studio. Before I jumped into that, I decided a value painting would be a good idea. Not only would that allow me to get a look at the composition in values, it would let me reacquaint myself with the day and the scene.

MATERIALS

OILS
Chromatic Black, Titanium White

SURFACE
8" × 10" (20cm × 25cm) primed linen

BRUSHES
Assortment of hog-bristle brushes

OTHER
Odorless mineral spirits

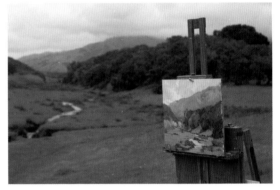

REFERENCE PHOTO WITH COLOR STUDY
Once you've done a color study and taken a reference photo, the next step is to create a value study.

1 **Establish the Horizon Line**
On an untoned canvas, lay down the horizon line. Place the horizon relatively low on the canvas to create more space for the sky and mountains.

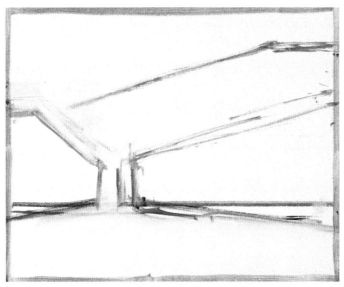

2 Block In Abstract Shapes

Mark the focal area, then work back from that, creating large, abstract shapes that represent the subject. The vertical and horizontal lines stabilize and slow down the diagonal movement of the hill shapes.

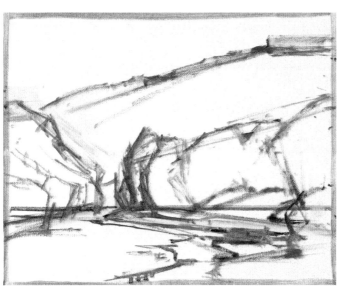

3 Refine the Basic Shapes

Thin the paint with OMS and draw in the contours of the hills, trees and river. Overlap the shapes to add depth.

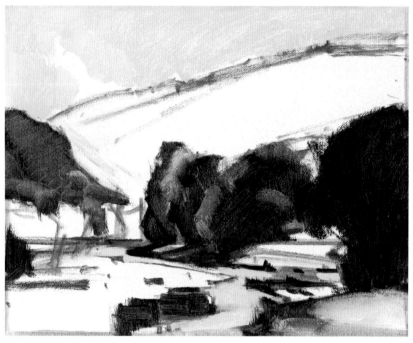

4 Paint the Dark and Light Areas

Paint the darkest shapes with Chromatic Black thinned with a bit of OMS. Paint a mid-light value for the sky, leaving the canvas blank where the lightest light will be in the sky. Wipe back lighter areas in the trees with a brush.

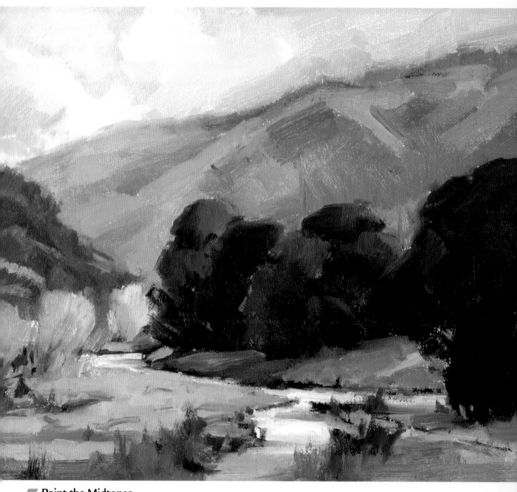

5 Paint the Midtones

After you have your darkest dark and lightest light figured out, paint in the middle tones. Use various grays to paint the values in flatly, then go in and lighten or darken each shape to give it form. Soften or sharpen edges where you need to while the paint is wet. The lightest areas should be the sky and the water where it reflects the sky. Since this is a cloudy rainy day, the value changes are not as strong as they would be on a bright, sunny, dry day.

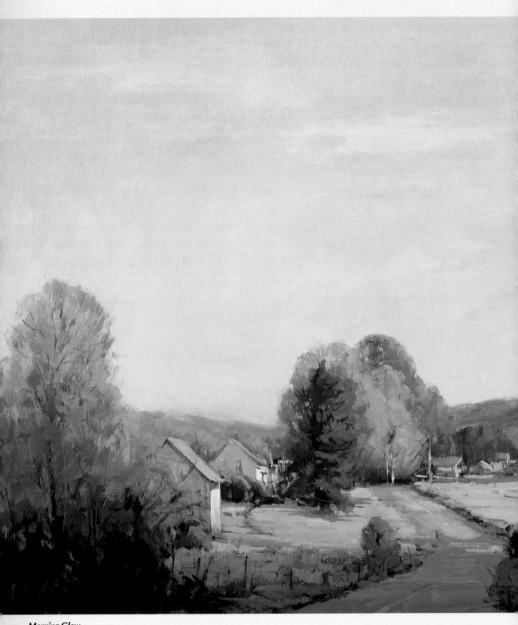

Morning Glow
Oil on linen
20" × 20" (51cm × 51cm)
Collection of Vartan & Nora Malian

4

COLOR & LIGHT

I was driving along the Santa Barbara coast, and the view of the cliffs was breathtaking. There was a "Santa Ana condition," which means that instead of the moist atmosphere we typically have on the California coast, the air was dry and clear. Normally, the moisture in the air causes a softening and graying of the light and color. That day, however, because of the Santa Ana, the light was warm and clear. Everything was crisp. The darks were dark and the lights were warm and brilliant. The shadows appeared cool in contrast to the light.

Understanding light is important for the landscape painter. Light affects the values seen in the subject matter and influences the colors as well. Atmospheric conditions affect the way light behaves and how colors appear in nature.

In this chapter you will learn how to use color to convey the look of the light and the feeling of the day in your landscape paintings.

What are the PROPERTIES OF COLOR?

Color has three main properties: hue, value and saturation. The light environment affects the appearance of colors. Compared to daylight, incandescent light (from light bulbs) has a yellow or orange quality, while fluorescent light (tubes) has a blue quality. The same color viewed in daylight looks different when seen in artificial light.

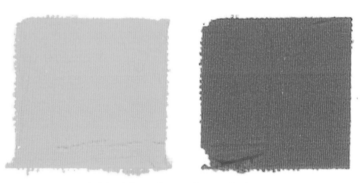

Cadmium Yellow Medium + Cadmium Red Light = orange

Mixed orange and Cadmium Orange

COLOR SATURATION
You can create a mixed orange, but the mixed color won't be as intense as a hue straight out of the tube.

Q What is a color's hue?

A *Hue* is the identity of color indicated by the color's name. The names green, blue and tan are labels that tell us a color's particular hue. There is a limited number of unique names for color (no matter what the language). For example, green and red are unique names. Reddish brown is a combination of names to describe this hue. Rose or turquoise are names derived from natural or cultural associations. Marketers have invented many, many names to describe various hues, such as harvest yellow or blue icing. We have a unique name for red mixed with white—pink—but we don't have a unique name for blue mixed with white.

Q What is color intensity?

A *Intensity* (also called *chroma* or *saturation*) is the purity of a hue compared with the same hue on the ideal color spectrum. Usually, a color is most intense in its purest form: straight out of the tube. The adjectives *bright* and *dull* refer to the relative intensity of a hue. Because a color becomes less saturated when it is mixed with any other color—including white—mixing tends to produce less intense hues.

Q What is a color's value?

A *Value* is the relative lightness or darkness of a color compared to a gray scale. For instance, yellow right out of the tube is light in value; Ultramarine Blue out of the tube is dark in value. Colors of various hues can have the same value. A black-and-white photograph of colorful objects or a photocopy of a color photograph will render color as black, white and grays.

The term *tint* refers to a color that has been mixed with white. Pink is a tint of red. Increasing the amount of white results in a higher value or a paler tint. The term *shade* refers to a color mixed with black. Increasing the amount of black results in a lower value.

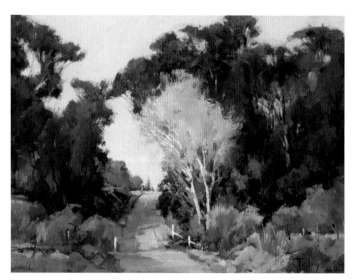

SEEING COLOR IN TERMS OF VALUE
Train your eye to see color in terms of value by looking at black-and-white versions of colored images. The black-and-white image shows how colors of various hues can have the same value. Making a black-and-white copy or taking a black-and-white photo of your work is a quick and easy way to determine the value relationships among the different hues in your subject.

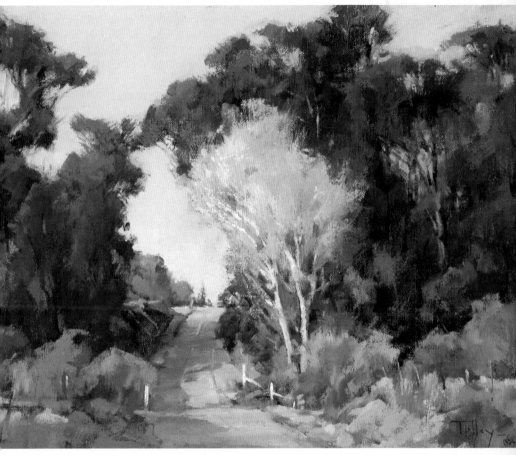

SAME VALUE, DIFFERENT HUES

Here you can see how I used different hues with the same value to create an eye-catching color scheme. In the black-and-white image on page 88, the green trees seem to have the same dark value, but I used different hues of green to make the trees more interesting.

Morning on Torro Creek Road
Oil on linen on board
12" × 16" (30cm × 41cm)
Private collection

What can I learn from the COLOR WHEEL?

A color wheel demonstrates color relationships. The *primary colors* (blue, red and yellow) are directly across from their complementary opposites (orange, green and purple, respectively). Orange, green and purple are also called *secondary colors* because each is created by mixing two primaries.

Between each primary color and secondary color is a *tertiary color* such as yellow-green between yellow and green, and yellow-orange between yellow and orange.

Colors close together on the color wheel (yellow-green, green, and blue-green, for example) are called *analogous colors*. The color wheel also illustrates color temperature. The reds, oranges and yellows on one side are the warm colors, and the blues, greens and purples on the other are the cool colors. The color wheel also shows graphically how color temperature is relative.

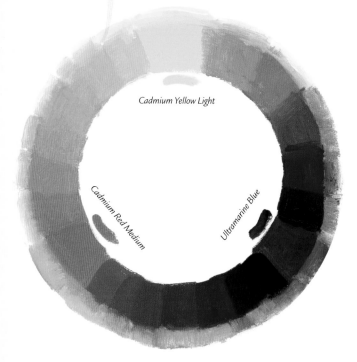

Cadmium Yellow Light

Cadmium Red Medium

Ultramarine Blue

COLOR WHEEL WITH PRIMARY COLORS

I made this color wheel using the three primary colors. I created a new hue by adding a little of the adjacent color to it. For example, I blended Ultramarine Blue and Cadmium Yellow Light together in different ratios to produce the five different green mixtures seen here.

For example, red is warm compared to blue-green or blue, but cool compared to orange. Start with any color; the colors will get cooler as you move in one direction, warmer in the other.

Making your own color wheels with the pigments you use will let you see the endless varieties and intensities possible in your color palette. As you mix your colors and place them in their appropriate spots on the color wheel, you will see the difference between cool and warm colors (see page 96). As you mix across the palette, you will learn more about intensities, as well as how the complementary colors work.

Color wheels printed in a book do not allow you to experience how the colors work with and relate to one another. By actually blending the colors yourself, your awareness of color relationships and values will grow and you will be able to create the colors you need for your paintings.

Q **Should I arrange colors on my palette according to the color wheel?**

A Many artists arrange the paints on their palette in the same order as in a spectrum or color wheel, with yellows on one end, reds in the middle and blues on the other end. The warm blue is next to the cool red, the warm red next to the warm yellow and so on to facilitate mixing purples and oranges. Whatever arrangement you choose, always place the same colors in the same order on your palette so you can get into the habit of placing your brush in the color you want without hunting for it.

How do I remember the properties of each COLOR?

Making a color chart will prove valuable for two reasons. First, you will get to know your paint mixtures and hues. Second, if you take the time to label your charts, you will have a wonderful reference of color mixtures that you can refer to in the future. The charts will enable you to mix your paints quickly and cleanly when you need to do so for your paintings.

One of the things you will learn as you make your color charts is how fast a color grays down when you add white. The colors that gray down quickly have low tinting strength. Some pigments,

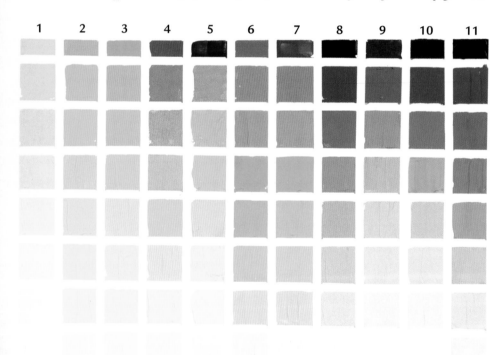

COLOR CHART OF CADMIUM YELLOW LIGHT

A reference chart such as this can help you find a specific color. Create a grid of masking tape on a board. Along the very top row, apply the color of each hue right out of the tube. In the next row, mix Cadmium Yellow Light with the other hues. In the succeeding rows, add Titanium White in increasing amounts to each mixture. In the first column, mix Cadmium Yellow Light with Titanium White to create a variety of tints.

1 Cadmium Yellow Light
2 Cadmium Yellow Deep
3 Cadmium Orange
4 Raw Sienna
5 Transparent Red Oxide
6 Cadmium Red Medium
7 Quinacridone Rose
8 Ultramarine Blue
9 Cobalt Blue
10 Viridian
11 Chromatic Black

such as Phthalo Blue and Phthalo Green, are staining hues and can take over a color mixture. Other pigments, such as Cobalt Blue, are less commanding in paint mixtures; thus their tinting strength is weaker. The new colors that have been produced chemically are usually transparent or semitransparent and make great glazing colors. They also do not gray down when white is added. For example, Viridian and white create a low-intensity (grayed) tint. Phthalo Green and white create a high-intensity tint.

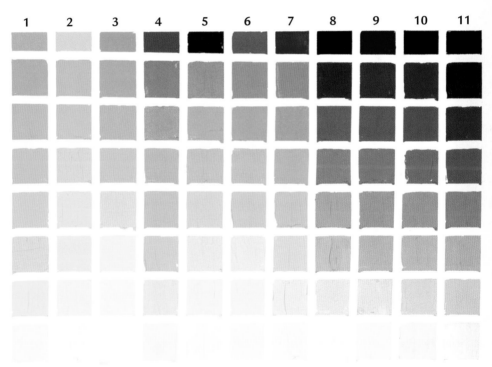

COLOR CHART OF CADMIUM YELLOW DEEP

Here you can see the colors you can create by mixing the same palette with Cadmium Yellow Deep. Notice the different results these yellows produce.

Color charts help you find the color you are looking for and how to mix it. After a while you will be able to look at a color in the landscape and know how to achieve it with paint. For example, you will know if you want to use a warm yellow or a cool yellow to achieve the green you want. By understanding your color mixes you are increasing your visual vocabulary. Do a color chart for all the colors in your palette.

1 *Cadmium Yellow Deep*
2 *Cadmium Yellow Light*
3 *Cadmium Orange*
4 *Raw Sienna*
5 *Transparent Red Oxide*
6 *Cadmium Red Medium*
7 *Quinacridone Rose*
8 *Ultramarine Blue*
9 *Cobalt Blue*
10 *Viridian*
11 *Chromatic Black*

How do I determine
a COLOR'S VALUE?

To determine a color's value make a value/color comparison chart. Paint a swatch on the chart. Some colors appear to be lighter or darker in value than they actually are because of their intensity or temperature. Keep this chart on the side of your palette to use as a quick visual reference to help you determine a color's position on the value scale.

Getting the right value is often more important to the overall success of your painting than exactly matching the color you see. Using your value/color chart will let you know if you will need to lighten or darken a hue to reach your desired value.

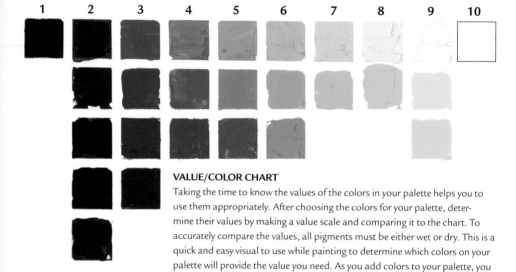

VALUE/COLOR CHART

Taking the time to know the values of the colors in your palette helps you to use them appropriately. After choosing the colors for your palette, determine their values by making a value scale and comparing it to the chart. To accurately compare the values, all pigments must be either wet or dry. This is a quick and easy visual to use while painting to determine which colors on your palette will provide the value you need. As you add colors to your palette, you can add them to your value/color chart for future reference.

1 *Value 1 = Ivory Black*
2 *Value 2 = Alizarin Permanent, Ultramarine Blue, Sap Green, Transparent Earth Red*
3 *Value 3 = Quinacridone Rose, Cobalt Blue, Viridian*
4 *Value 4 = Quinacridone Red, Cerulean Blue*
5 *Value 5 = Cadmium Red Light, Raw Sienna*
6 *Value 6 = Cadmium Orange, Yellow Ochre*
7 *Value 7 =Cadmium Yellow Deep*
8 *Value 8 = Cadmium Yellow Medium*
9 *Value 9 = Cadmium Yellow Light, Cadmium Yellow Lemon*
10 *Value 10 = Titanium White*

 How can I learn to paint the values I see in the landscape?

A Use fresh paint to make a value scale on one side of your palette. While you can put a value scale under the glass on your palette, the comparisons will not be as accurate as comparing wet paint to wet paint. Having the wet value scale on your palette will let you mix the appropriate values and will help you paint in the correct value range. This tool is very valuable while painting outdoors where light bounces into the palette. It is also valuable to be able to check a mixture of paint and make sure it is the value you want before you lay it on your canvas.

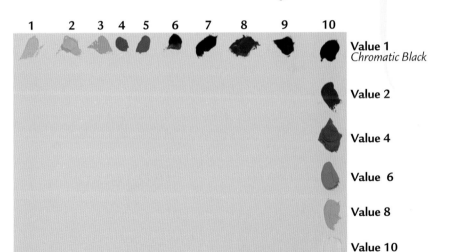

Value 1
Chromatic Black

Value 2

Value 4

Value 6

Value 8

Value 10
Titanium White

PALETTE WITH VALUE SCALE

I have found it very helpful to have my palette set up this way when working in a studio or under less-than-perfect lighting conditions. Mixing fresh grays on my palette has become part of the way I work.

Left to right:
1 *Cadmium Yellow Light*
2 *Cadmium Yellow Deep*
3 *Cadmium Orange*
4 *Raw Sienna*
5 *Cadmium Red Medium*
6 *Quinacridone Rose*
7 *Ultramarine Blue*
8 *Cobalt Blue*
9 *Viridian*
10 *Chromatic Black*

What is COLOR TEMPERATURE?

Artists use the term *color temperature* to describe the relative warm or cool feeling of the light and color of a painting. A successful painting will have a consistent temperature.

A landscape painter needs to understand the concept of color temperature to be able to use color to create appropriate effects of light and shadow. For instance, when you have cool light, your shadows will be warm; if the light is warm, the shadows are cool. However, a cool shadow does not have to be cold; the color just needs to be cooler than the areas not in shadow.

Color temperature is relative. All reds are warm compared to blue, but Alizarin Permanent, a red, is cool compared to Cadmium Red Light, another red. On page 12, the suggested selection of colors for your landscape palette included a warm and cool version of each of the primary colors.

Temperature is also a quality of light. The color of the daylight changes with the time of day. Natural light affects the colors in a landscape, so the artist must be sensitive to the temperatures that appear in order to recreate the correct quality of light in the painting.

Warm *Cadmium Yellow Medium* **Cool** *Cadmium Yellow Lemon*

COMPARING COLOR TEMPERATURE
Notice the difference between the warm yellow and the cool yellow when they appear side by side. On their own, either yellow could pass for warm.

Q Why should I have a warm and a cool of each color?

A Having a selection of warm and cool pigments lets you arrive at the mixtures you want more quickly and it gives you opportunities to have more color variations. Green is a good example of this. Using your warm yellow and warm blue will create a very different green than your cool yellow and cool blue (the same is true for your yellows and reds and your reds and blues). You will see these variations on your color charts.

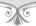

PREDOMINANTLY WARM PAINTING

Late afternoon light had turned this landscape golden. The light is predominantly warm, but the few cools give a nice contrast in both temperature and color.

Evening Gold
Oil on linen on board, 12" × 12" (30cm × 30cm), Collection of the artist

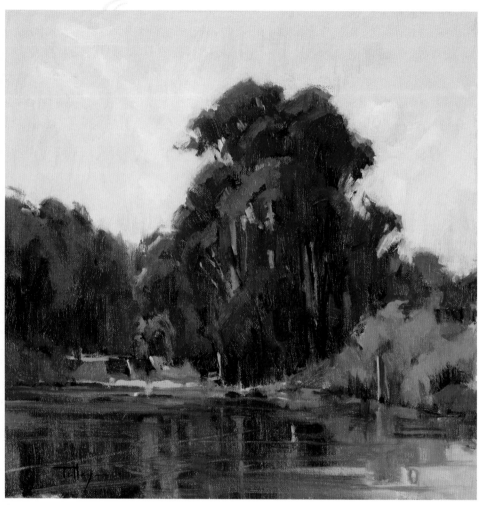

Summer Greens
Oil on linen on board
12" × 12" (30cm × 30cm)
Private collection

PREDOMINANTLY COOL PAINTING

In this painting the light has a cool temperature, and the areas out of the light have a warmer look. The yellows lean toward green, not red, so they are cooler. The cool blue sky color influences the dominant greens. Touches of complementary red add a bit of vitality and contrast.

How does LIGHT affect the LANDSCAPE?

Light can generally be described as warm or cool. Sometimes it's intense, other times it's diffused. The characteristics of light on any given day can transform a landscape. Light may change due to the time of day, the season (which affects the direction of the light) and the atmospheric conditions. A cloudy day will make the colors in a landscape look cooler while the moisture in the atmosphere can make the colors less intense.

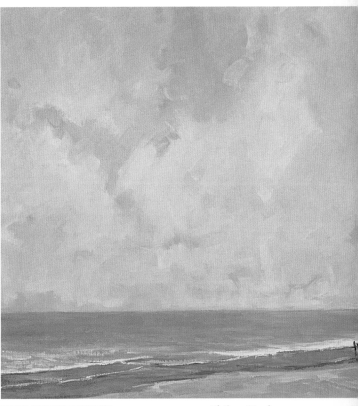

COOL MORNING LIGHT
The morning light coming through this clearing sky was very cool, and its intensity was lessened because of the moisture in the air. The touch of warmth in the small figures on the beach creates a contrast.

Platinum Morning
Oil on linen on board
22" × 22" (56cm × 56cm)
Collection of the artist

At sunrise, early morning, late afternoon and sunset, the sun is closer to the horizon, so the sunlight is filtered through more atmosphere and has a noticeably different temperature. Late afternoon light is especially dramatic, with lots of orange and pink tinges. At midday, the sun is directly overhead, so colors are illuminated by unfiltered "white" light; that is, light that is neither cool nor warm compared to other times of day.

Afternoon on the Wye River
Oil on linen on board
12" × 12" (30cm × 30cm)
Collection of the artist

MID-AFTERNOON LIGHT

In this *plein air* painting, my aim was to capture the light and color as I saw it. The light is on the top of the trees, land and water. The humidity was high. Note the absence of strong shadows.

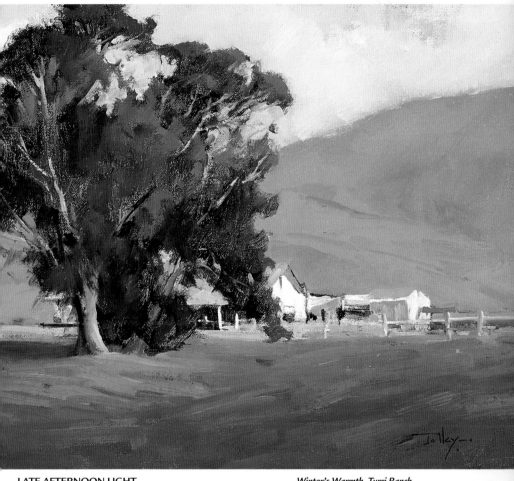

LATE AFTERNOON LIGHT

Afternoon light has a warmth to it. The warm yellows, oranges and reds are the colors of the late afternoon and evening. All the areas in light in this piece are touched with this warm light, which unifies the composition. The blue of the roof includes some yellow and a touch of orange, creating a warmer hue.

Winter's Warmth, Turri Ranch
Oil on linen on board
14" × 18" (36cm × 46cm)
Collection of Adian & Richard Lenz

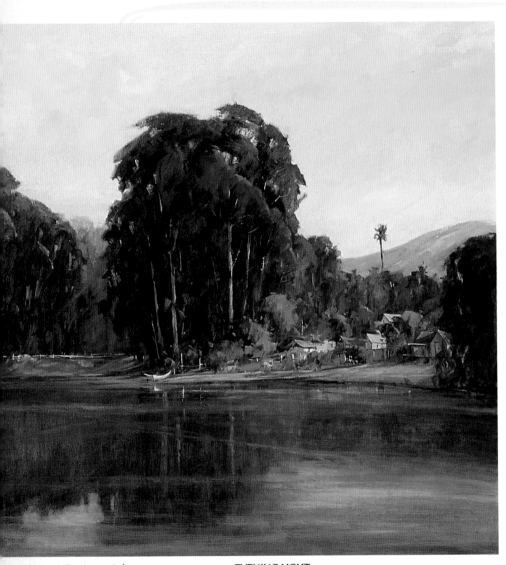

Summer's Eve, Laguna Lake
Oil on linen
36" × 36" (91cm × 91cm)
Private collection

EVENING LIGHT

As the sun goes lower in the sky, the reds and oranges dominate everything in the light. As you mix your tints, make sure they contain some of the warm colors that represent the light. The cooler boat in the water creates some contrast.

How can I create a SENSE of LIGHT in my paintings?

To create a sense of warm light in your paintings, paint the areas that are illuminated by sunlight warmer in color and lighter in tonal value. Areas in shadow should be cooler in color and darker in tonal value. The color and value contrast will create the sense of light. Making the contrast greater—even warmer and lighter colors in light and even darker and cooler colors for shadow areas—will make a more dramatic statement. For cool light, paint the areas in shadow warmer (they don't need to be hot, they just need to be warmer than the cool light).

Be consistent with your treatment of the light and shadow. The light on a landscape is constantly changing, so you should aim to capture a single moment. Sunlit areas and shadows that are not consistent will weaken the sense of a specific time of day in your painting.

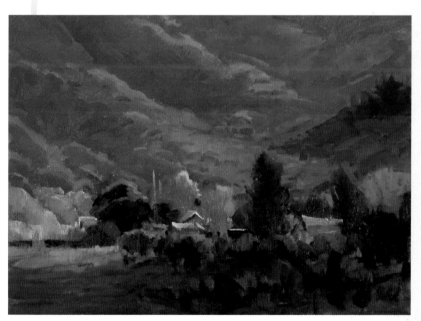

CONTRAST AND CONSISTENCY
Notice how warm light comes from the upper right and is consistent on the background hillsides and the midground trees and buildings. The areas not in light are cooler, darker and less intense. This contrast gives the picture a strong sense of light at a particular time of day.

Winter Afternoon
Oil on linen on board
11" × 14" (28cm × 36cm)
Collection of the artist

103

How does the ATMOSPHERE affect a LANDSCAPE?

The moisture and particulate matter in the atmosphere make distant objects look softer, cooler, duller and lighter—a phenomenon that artists mimic with *atmospheric perspective* (see page 137). Often the contrast between foreground areas, with their sharp detail and stronger value and temperature differences, and distant objects rendered with less detail and contrast will give a painting a greater sense of depth.

On a really clear day, distant objects, such as background hills or offshore islands may be distinct, with sharper detail visible and greater color and value contrast. Dense fog or mist, heavy smoke or even pollution can make distant objects look lighter and cooler, with soft edges and no detail.

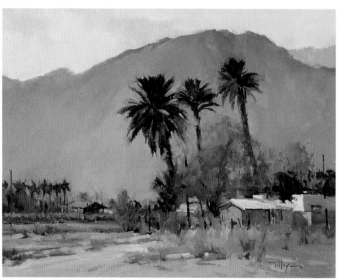

Color of Morning
Oil on linen on board
14" × 18" (36cm × 46cm)
Collection of James & Mara Lehrer

ATMOSPHERIC PERSPECTIVE
By keeping the light warm and the shadows cool, I was able to show the cooling influence of the sky. As I painted the distant areas, I muted the colors, reduced the contrasts and softened the edges. The warm red on the mountain is much cooler and the color less intense than the sunlit reds that are closer to the viewer.

How do I
LIGHTEN A COLOR?

In order to achieve the desired value of a color in your painting, you might need to lighten or darken it.

There are two ways to lighten your colors. You can add white or a color of a lighter value. Adding white or any other color will change a color's hue and intensity in addition to its value, so mixing colors must be done with care.

Adding white produces a *tint*. Some colors have greater *tinting strength* and retain their color identity when mixed with white or other colors, while others have less tinting strength and become less intense (grayed) when mixed with white.

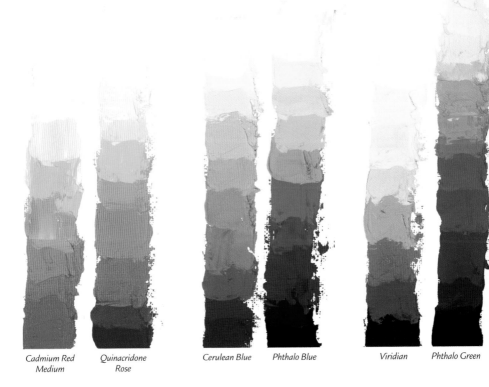

| Cadmium Red Medium | Quinacridone Rose | Cerulean Blue | Phthalo Blue | Viridian | Phthalo Green |

HOW DOES TINTING STRENGTH AFFECT MY COLOR CHOICES?

Tinting strength refers to how well a color stands up to mixing. Viridian has a low tinting strength in comparison to Phthalo Green. Viridian will lose its color intensity easily. Phthalo Green, a synthetic (or modern) pigment, will keep its intensity when white is added. To gray a synthetic color like Phthalo Green you can add its complement, Quinacridone Rose (another synthetic pigment with like tinting strength) or add a gray made from Chromatic Black (also a synthetic pigment) and Titanium White.

Adding a color of lighter value will alter the hue, reduce intensity, and possibly change the temperature. For instance, mixing yellow, a color of light value, into Viridian, a dark green, will produce a lighter green. This green will be less intense than the yellow and lighter in value and warmer than the Viridian. Adding white to the mixture will produce a tint of even lighter value, but of even less intensity. It will also make it cooler.

MAINTAINING COLOR IDENTITY

The color identity of the yellow-green at the near left is lost and becomes a grayed cool white. In the example at the far left, I lightened the mixture of Cadmium Yellow Light and gray with white, then added Cadmium Yellow Light back into the white to maintain the color identity of the yellow.

Color identity retained *Color identity lost*

Q When should I lighten the value of a color by adding another color?

A If you want to lighten a color yet maintain the original color's identity, add another color along with white. For example, to lighten orange you can add some yellow. If you want to lighten Cadmium Red Light but keep its warmth, add some dark yellow; however, if you want to lighten and cool Cadmium Red Light, Medium or Deep to a pink, then use white to lighten it. If this becomes too gray, you can add some Quinacridone Red or Quinacridone Rose to the mixture. The Quinacridones have strong tinting strength, so they will quickly affect the mixture.

How do I
DARKEN A COLOR?

In order to achieve the proper balance of tonal values in your paintings, you will need to darken as well as lighten the paints that come from the tube. Just as with adding white, adding one color to darken another will change the value, hue, intensity and temperature.

Although you can simply add black to darken a color, there are a number of great substitutes that you can mix that make lively alternatives to black. You can also darken a color with a deeper hue or its darker complement. For instance, if you want to darken Cadmium Red Light, Medium or Deep and remain in the red family, you could darken it with Alizarin Permanent. If that seems too cool, you could choose Transparent Red Oxide. Creating color charts as you experiment with darkening or lightening your colors will make finding the right shade or tint easier.

Q What are some good mixed blacks?

A Any of these alternatives to black can be used to darken a color. Each one will react a bit differently when mixed with other colors, so experiment with them. Making a chart of the mixtures is a highly recommended and interesting exercise.

- Viridian + Cadmium Red Deep makes a rich, semiopaque black that grays to a violet-gray or green-gray, depending on the amount of red or green in the mixture.
- Ultramarine Blue + Cadmium Orange makes another semi-opaque black. Add Titanium White for a nice warm or cool gray (depending on the amount of blue or orange).
- Ultramarine Blue + Transparent Red Oxide creates a rich, transparent black. Add Titanium White for a beautiful gray.
- Quinacridone Rose + Phthalo Green makes a cool, transparent black with high tinting strength.

Q How do I darken a color without changing the hue?

A You can darken a color by adding a darker color of the same hue. Use Ultramarine Blue to darken Cobalt or Cerulean Blue. Alizarin Permanent can darken the other reds. Cadmium Yellow Deep can darken Cadmium Yellow Light. Raw Sienna is a yellow brown that can be used to darken a yellow without destroying its yellow nature.

Ultramarine Blue + *Cerulean Blue =* *a darker blue*

Cadmium Yellow Medium + *Cadmium Yellow Light =* *a darker yellow*

How do I darken a color without using black?

A Another way to darken a color is to add a bit of its comple-ment—the color on the opposite side of the color wheel. Adding purple to yellow will make it darker and less intense. Adding red to green or blue to orange will produce the same result. This only works if the complement is darker than the color you want to darken. If you want to darken a color already low in value, such as Ultramarine Blue, you will need to add black.

Purple (Ultramarine Blue + Alizarin Permanent) + *Yellow (Cadmium Yellow Medium) =* *a darker yellow*

Black (Viridian + Cadmium Red Deep) + *Red (Cadmium Red Light)=* *a darker red*

How do I mix
LUMINOUS GRAYS?

A painting made entirely of high-intensity colors would be overwhelming. It's the painterly equivalent of a shouting match. A few colors in a painting may shout, but some should also whisper. I like to think of subdued colors as whispers. Grays are the most common examples of subdued colors, but just because they are subdued doesn't mean they are boring. Grays come in two basic types. Colorful grays are created by mixing colors other than black and white. Mixing black and white produces neutral grays, or grays with no hint of color in them. Neutrals grays are great for a value studies, but can be monotonous.

Colorful grays are not dull. The basic formula for a luminous gray is to mix a color with its complement. For instance, mix a blue with an orange and the resulting gray will be more vibrant than

COMPLEMENTARY GRAYS
Grays made with color complements retain a color identity and luminosity.

Ivory Black + Titanium White (neutral gray)

Purple (Ultramarine Blue + Quinacridone Rose) + Titanium White + Cadmium Yellow Light

Ultramarine Blue + Titanium White + Cadmium Orange

Viridian + Titanium White + Cadmium Red Light

either color mixed with black. You can change the temperature by adjusting the proportions of the mixed colors.

Colorful grays have many uses in a landscape. Rocks, soil, tree trunks, clouds and people are obvious uses. But the real power of colorful grays is their use in support of more intense colors. A basic principle in color theory is *simultaneous contrast*. This principle states that the appearance of a color is greatly affected by the colors around it. For example, a green looks much greener when surrounded by reds than when surrounded by blues. A color's apparent hue, value and intensity can be increased by placing it in a field of contrasting hue, value and intensity. Colorful grays can provide a good contrasting field to bring out the best in other colors. For example, to make a house with white walls look like it is bathed in sunlight, add a touch of Cadmium Yellow to the white wall in light, but use a cool, luminous gray of mid to dark value for the walls in shadow. Both the cool color and darker value of the shadow will make the sunlit wall glow by contrast.

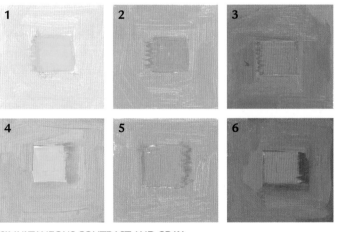

1 Cadmium Yellow Medium in a neutral gray
2 Cadmium Orange in a neutral gray
3 Cadmium Red Light in a neutral gray
4 Cadmium Yellow Medium in a gray made from Cadmium Yellow Medium, Quinacridone Rose, Ultramarine Blue and Titanium White
5 Cadmium Orange in complementary gray made from Cadmium Orange, Ultramarine Blue and Titanium White
6 Cadmium Red Light in complementary gray made from Cadmium Red Light, Viridian and Titanium White

SIMULTANEOUS CONTRAST AND GRAY

The pure pigments surrounded by complementary grays appear more luminous than those surrounded by neutral grays. To make a color appear even more intense, place it next to a complementary color. This will make the color vibrate. A small of amount of pure color in a grayed painting will make the painting feel colorful.

How do I mix the GREENS I see in the LANDSCAPE?

Greens are some of the most common colors a landscape painter needs to mix. Trees, leaves, and grass are the predominant components of many landscapes, and most likely the various greens you see in them will not match any paint that comes out of a tube. Start by trying to classify the type of green you are seeing; consider whether it's a blue-green, yellow-green or a reddish green, for instance. Notice how the green relates to the colors around it, and determine whether it is warm or cool, dark or light, intense or grayed.

Once you establish the identity of the green you are seeing, refer to your color wheels and charts to select the appropriate hue of green, then determine what colors you used to mix it. Try making a chart with Viridian and the blues along the top, and the yellows, siennas and ochres down the side. In the squares, mix each color on the top with each color on the side. Add a little white to the color to make a tint.

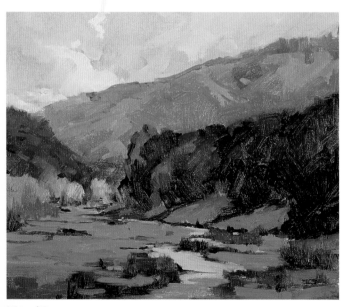

SELECT GREENS BASED ON COLOR TEMPERATURE AND SURROUNDINGS
I painted this scene in late morning. The sky was heavy with moisture, which muted and cooled the greens. Even though the light was cool, the foreground seemed warmer than the background, so I made the foreground greens warmer. As I moved away from the foreground, I used lighter and bluer shades of green.

Wet and Green
Oil on linen on board, 10" × 12" (25cm × 30cm), Collection of the artist

Because there are so many formulas for mixing greens, selecting the right one can be overwhelming, even for the more experienced painter. One strategy to simplify mixing a variety of greens and still maintain an overall unity of color in your painting is to select a "base green" and use it as the starting point for all the other greens in your landscape.

One such "base green" is Ultramarine Blue and Cadmium Yellow Light. Mix a quantity of this blend on your palette in the beginning, and use it as base for the other greens you need for your landscape. You can push this mixture warmer with Cadmium Yellow Deep, grayer with Cadmium Red Light or greener with Viridian. To make the mixture cooler, add more Ultramarine Blue or Cobalt Blue. If all of the greens in your painting begin with the same color, they will have a "familial resemblance" that will unify your composition.

Using Reds in Landscapes

Placing a red in a green landscape will always make the red appear even redder. Often the red needs to be grayed or neutralized to keep it from jumping off the canvas.

Q What are some common mixed greens?

A Here are some formulas for useful greens worth noting. For intense, purer and cooler greens, try the following:
- Ultramarine Blue + Cadmium Yellow Light
- Cobalt Blue + Cadmium Yellow Light
- Viridian + Cadmium Yellow Light

For less intense, warmer and vegetal greens, try the following:
- Ultramarine Blue + Cadmium Yellow Deep
- Cobalt Blue + Transparent Yellow Oxide
- Viridian + Cadmium Red Deep + Cadmium Yellow Light

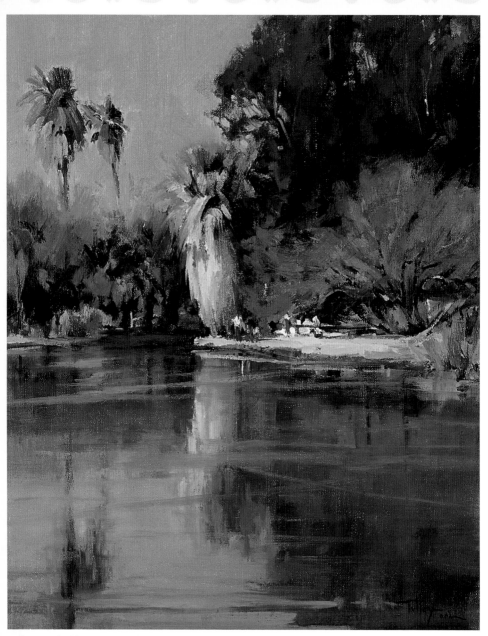

In the Warmth of the Sun, Agua Caliente
Oil on linen on board
18" × 14" (46cm × 36cm)
Collection of the artist

WORKING WITH A BASE GREEN

I mixed a variety of greens for this painting. Some of the dark, transparent greens were mixed with Ultramarine Blue and Transparent Yellow Oxide. Many of the greens began with a base mixture of Viridian and Cadmium Red Deep which made a dark gray-green. From this, I lightened and changed the greens by adding whichever colors would push the base color to the hue, intensity and value that I needed.

What is a good COLOR SCHEME for a landscape painting?

One simple way to create a good color scheme for your painting is to choose most of your colors from the same temperature and tonal ranges. Use colors of opposing temperature and value as accents. A small bit of highly contrasting color should be reserved for the focal point. For example, a painting of an early summer field with trees reflecting into a pond would probably be mostly green. The light would either be warm or cool and the shadows would contrast with the light. The dominant values would depend upon how and when you choose to paint the scene. Is the scene mostly in shadow or in light? One of these should be dominant. Contrasting values give the painting vitality, keeping it from being too peaceful or even monotonous. Including cattle or structures add color accents and their shapes add interest.

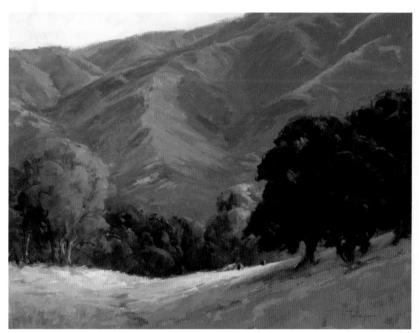

WARM LIGHT AND COOL SHADOW
This painting is mostly in shadow, with green the dominant color. The warm reds and oranges provide a welcome contrast. The center of interest has the most intense contrast and color. However, it is not strong enough to keep the eye from moving around the rest of the painting.

Evening Grace
Oil on linen on board
16" × 20" (41cm × 51cm)
Collection of the artist

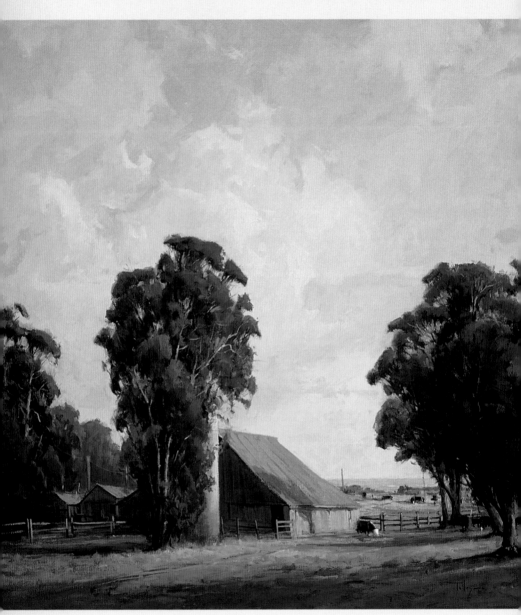

Surrender to Evening
Oil on linen
30" × 30" (76cm × 76cm)
Collection of Arthur Ermish

5

TECHNIQUES

Mastering the artist's visual language requires a knowledge of technique. While subject and composition carry the idea, the way we handle the paint and brushes is how we visually express the information on canvas. This is the craft of our art.

My advice to my workshop participants and those of you reading this book is to slow down to hurry up. Take the time to think out the stroke you want to make. Take the time to think out what color mixes you need and how you want to apply the paint. Practice glazing and scumbling. Find a method that works with your personality and the time you have to paint.

Don't be afraid to overwork a painting to understand where it is you are trying to go. Then use it as a study to make your masterwork. My closets and flat files are filled with studies—some good, some not so good. However, I have learned something from all of them. I can look back at those studies when I am looking for a solution for a piece I am getting ready to paint. They are part of my library of knowledge.

Be willing to let go of the product, and get into the process. In the end you will find your work becoming more fluid and confident.

How do I create a VARIETY OF BRUSHSTROKES?

Create variety in your painting by using your brush in different ways to produce more interesting marks. You do not have to have lots of brushes. Variety can be achieved by how you hold your brush, how much pressure you apply to the brush, and how much paint you have on the bristles.

worn

new

NEW VS. WORN BRUSHES
Try laying down paint with a new brush and a worn brush. Notice how the new brush has bounce and flexibility in the bristles, letting you put down the paint in a broader stroke. A worn brush is great for scrubbing in texture, but when you want to lay down broad strokes of paint, reach for your new brushes.

Q What is a loaded brushstroke?

A A loaded brushstroke is used to apply a heavy layer of paint. Use a loaded brush when you want to put another layer of wet paint on a previously painted surface without intermingling or intermixing the colors. As your painting progresses, you will want to apply thicker deposits of paint. Usually the initial phase of a painting is done with a very thin layer of paint mixed with a bit more solvent in the medium to block in the color and value pattern that will be developed in subsequent phases. Sometimes the initial phase is an underpainting of contrasting colors upon which thicker layers of paint will be deposited. In order to apply the overcoats of paint, you need to use thicker paint either with more medium and less solvent or with no medium or solvent, and apply it with a loaded brush.

Q How do I create expressive brushstrokes?

A How you hold the brush, how quickly you move the brush on the canvas, and how much pressure you apply to the canvas will affect the brushstrokes you create. Holding the brush handle far away from the tip and applying light pressure will produce brushstrokes that are almost calligraphic in character. These strokes look lively and energetic; however, this method gives you less control.

Holding the brush closer to the bristles and using heavier pressure will create stiffer, less fluid and shorter strokes, but you will have more control. These strokes tend to scrub the canvas, mixing the paint on the brush with the paint on the canvas more thoroughly. Try to paint with your hand farther back on the brush.

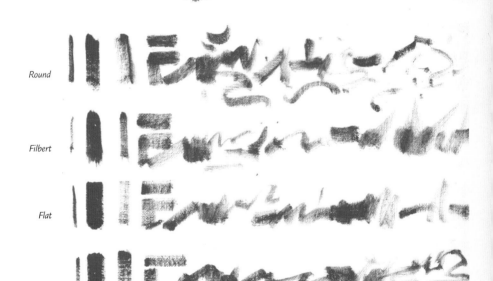

Round

Filbert

Flat

Bright

BRUSHSTROKE PRACTICE

The amount of paint you put on your brush and the pressure you exert will create different marks. Try turning your brush as you paint; this creates a lively mark. Do this with your brushes to see the types of marks your brushes can make.

119

Q How do I create a dry-brush application?

A If you want to create a dry-brush application (where the paint drags on the canvas, creating areas of broken color), use paint that is "stiffer," that is, not thinned with medium or solvents, don't load too much on the brush, and apply it with a light touch, dragging the brush lightly over the surface of the painting. Dry brushing won't work if the paint already on the canvas is too wet.

Q How do I create "quiet" areas?

A Not every part of your painting should have lots of texture and active, energetic brushstrokes. Some areas should be quiet areas, or areas that don't have a lot of activity in terms of brushstrokes and texture. Quiet areas provide a rest area for the eyes. They also provide contrast to the active areas. To create a quiet area, subdue your brushstrokes by making them softer. Another way to create a quiet area is to include less color and value variations.

Q How do I change a brushstroke?

A The best way to correct a stroke or to remove paint from the canvas is to use a rounded painting or palette knife to lift it off. Gently pull the palette knife up and off the canvas. Remember to clean the knife each time you lift the paint off so that you do not put paint back on the canvas.

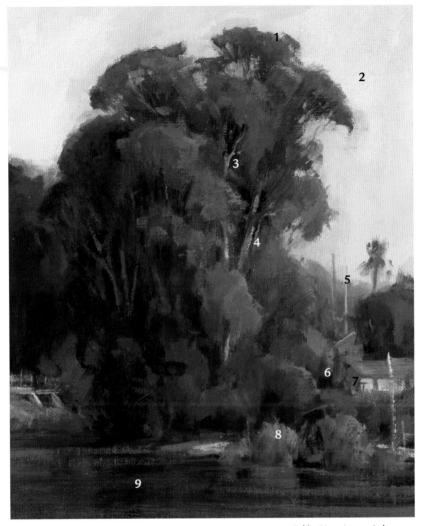

USE A VARIETY OF BRUSHSTROKES

Different types of brushstrokes can create an exciting image.

Golden Hour, Laguna Lake
Oil on linen
10" × 8" (25cm × 20cm)
Collection of the artist

1 *Broken brushwork creates a softened edge*
2 *Soft edges*
3 *Dry-brush application*
4 *Loaded brush creating short, crisp edges*
5 *Soft, blended edge*
6 *Soft edge*
7 *Hard edge*
8 *Loaded brushstroke*
9 *Horizontal strokes with soft edges*

How do I CREATE INTERESTING EDGES?

You can achieve interesting edges in your painting in different ways. Changes in value and color can create edges, as can your method of applying paint. There are two basic types of edges: hard and soft. Either type can be made with your flats, brights, filberts or rounds. Specialty brushes (such as riggers and script liners) are good for drawing lines and marks.

CREATING SOFT AND HARD EDGES

You can create a hard edge with a change of value or color. To soften an edge, pull your brush into the next color. This will create a halftone and the hard edge will become "lost." Generally, the edge of an object will appear broken where the light hits it. To show that in your painting, use a softened or lost edge.

Q What are hard and soft edges?

A *Hard* and *soft* (or *found* and *lost*) are terms used to describe the ways edges may be handled in a painting. A hard edge is crisp and well defined, while a soft edge is blurred.

Q How do I create a soft edge and where should I use it?

A A soft edge can be made with brushstrokes that merge into each other. You can also create soft edges with values that are so similar that there is not much value contrast. You can create a soft edge by stroking the brush over the edge either in the same direction or perpendicular to the edge. You also can soften edges by passing a large soft brush lightly over the area you want to blur. Soft edges vary in degree. Some are irregular or very blurred, others more distinct but not sharp.

Use soft edges to describe round or curved edges. Objects such as trees and clouds that are directly hit or haloed by the light can be rendered effectively with soft edges. Use soft edges for distant objects or for any edge that you don't want to compete with the center of interest.

Q How do I create a hard edge and where should I use it?

A A hard edge creates a visual contrast that becomes a natural "eye magnet." A hard edge is created when two shapes of contrasting hue, value or intensity butt against each other. If all three characteristics are too similar, the edge will not be very noticeable no matter how sharp and crisp it is. You make a hard edge by applying the paint in a single steady stroke, pushing the paint against the paint already applied. Going over the stroke again will soften the edge.

Hard edges can be used to define objects with distinct edges, such as human-made objects, or natural things such as tree trunks or rocks. Only edges that you want to be the focal point of your composition should have sharp contrasts in hue (especially complementary colors), tonal value and intensity.

Hard and Soft Edges

Creating little sketches will help you work with edges. These sketches do not take long and will go a long way toward helping you with your painting technique. Remember, hard edges occur where there's strong contrast or straight edges. Soft edges occur on rounded objects or areas where the light hits and breaks the form.

MATERIALS

OILS
Cadmium Orange, Transparent Red Oxide, Titanium White, Ultramarine Blue

MIXTURES
Warm gray made with Cadmium Orange, Ultramarine Blue and Titanium White (Cadmium Orange dominant)

Cool gray made with Ultramarine Blue, Cadmium Orange and Titanium White (Ultramarine Blue dominant)

SURFACE
Acrylic-primed canvas board

BRUSHES
Nos. 4 and 5 hog-bristle flats, no. 2 hog-bristle bright, no. 3 script liner

OTHER
Odorless mineral spirits

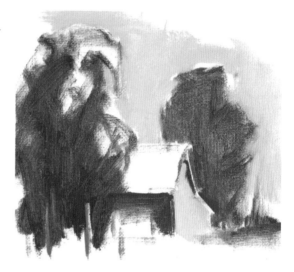

1 Establish the Basic Shapes
Lightly draw with paint the silhouette of the shapes on the canvas with a no. 2 bright. Lay down a dark warm gray in the trees, barn and land with a light hand and the no. 4 flat. Lay down a cool light gray in the sky. Use a light warm gray on the barn to create a hard edge where the light and shadow meet on the barn. Keep the edges soft for the trees and the top of the barn.

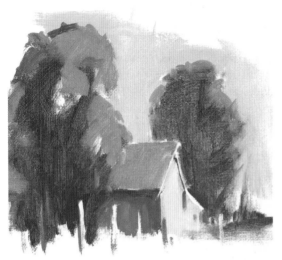

2 Build the Forms

Continue to build the trees, barn and ground. Add a cool gray over the dark warm gray, allowing some of the first layer to show through on the barn with a no. 5 flat. Where the corners of the barn meet, lay down light warm gray next to the cool gray and dark complementary colors to create a hard edge with your no. 4 flat. For studies it's more convenient to use one brush for your darks and another for your lights.

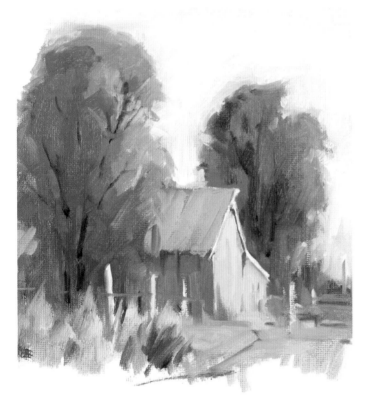

3 Complete the Study

For the grasses, apply a thin layer of warm gray, then overpaint with a thicker, lighter tint. Apply a tint of lighter cool gray over the darker gray of the sky. Pull your wet paint into other wet paint where the sky and trees meet, creating soft edges. Create the tree trunks and limbs with the script liner and a mixture of Ultramarine Blue and Transparent Red Oxide. Lay cool gray over the warm gray in the trees, and on the barn's roof create a soft edge where the sky and the barn meet. Create a hard edge where the light on the barn and dark of the trees meet.

How do TRANSPARENT and OPAQUE paints differ?

Transparent colors let light pass through while opaque colors obscure the light. Light travels through transparent paint and bounces off the canvas, while light bounces off opaque paint. You can make transparent pigments opaque by adding an opaque paint such as Titanium White. While medium can be added to opaque paint to make it less opaque, opaque paint will never make a good substitute for transparent paint because its chemical makeup is different. Choose transparent colors for glazing.

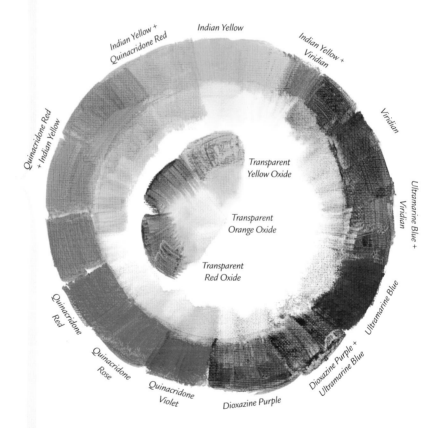

A TRANSPARENT COLOR WHEEL IS A HANDY REFERENCE FOR GLAZING
This color wheel is made from transparent colors. The oranges were made from two transparent colors, Indian Yellow and Quinacridone Red. The blue-green is a mixture of Viridian, a transparent color, and Ultramarine Blue, a transparent color. The green-yellow is Viridian mixed with Indian Yellow. The yellow-green would be much cooler and purer if it had been mixed with a cool transparent yellow that leaned to the green side such as Hansa Yellow Light. The Indian Yellow leans to the warm orange side, so it grays the blue-green Viridian.

1	2	3	4	5	6	7	8
2							
3							
4							
5							
6							
7							
8							

TRANSPARENCY CHART

Paint horizontal bands of color, starting with Indian Yellow and proceeding through the colors listed below. After the horizontal bands dry, paint down in columns of color, starting with Indian Yellow.

1 *Indian Yellow*
2 *Transparent Yellow Oxide*
3 *Transparent Red Oxide*
4 *Quinacridone Rose*
5 *Quinacridone Violet*
6 *Dioxazine Purple*
7 *Ultramarine Blue*
8 *Viridian*

Artist's Note

Applying transparent paint over other transparent paint can create a glowing stained-glass effect. Transparent glazes over opaque paint creates depth and can warm or cool a passage. Artists who include both transparent and opaque paints in their palettes expand their possibilities with paint by taking advantage of a wide array of characteristics.

Should I use a TRANSPARENT UNDERPAINTING?

Transparent paint and thinned opaque paint are different. Transparent paint has a much more luminous quality. To create a transparent underpainting, use transparent paint with a mixture of 1 part alkyd medium thinned with 2 parts odorless mineral spirits. You want to keep the wash thin without destroying the paint by thinning it too much with OMS. The wash should be thin, but not run off the canvas.

Direct Painting

Direct painting, or painting *alla prima*, is a method of painting in which the entire painting is completed in one sitting. The final results are achieved with only one application of paint.

Q Why should I use a transparent underpainting?

A A transparent underpainting allows you to establish the pattern of tonal values and color temperatures before applying thicker paint. You can block in the colors over the entire composition and evaluate its success before doing a lot of detailed overpainting. You can step back from the blocked in underpainting and look at it from a distance to evaluate how well the composition will work. The utility of such a transparent underpainting is the ease with which you can make judgments about the color and tonal value relationships for the overpainting. Beginning with an underpainting eliminates the speckles of white, unpainted canvas that often crop up in an *alla prima* painting.

While the underpainting is wet, you can easily make changes. For instance, you can wipe out areas that aren't working or change the shape of a silhouette with a cloth or brush.

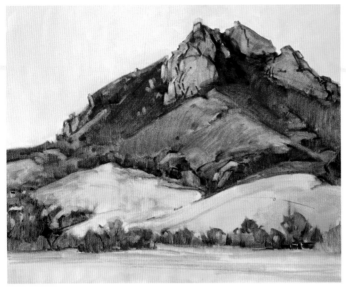

START WITH TRANSPARENT PAINT

When working on a large canvas, it can be helpful to get your design down with transparent paint before you start working with thicker paint. Here, the red violet areas will be a beautiful underpainting for the greens to follow because the red helps lower the greens' intensity.

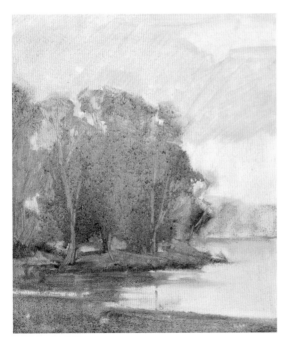

MONOCHROMATIC TRANSPARENT UNDERPAINTING

Here, I applied a transparent underpainting over a linen canvas toned with Raw Sienna. After that was dry, I applied a wash of Transparent Yellow Oxide, Cobalt Blue and Transparent Red Oxide. The shapes that appear lighter were wiped back with a damp brush to create the tree trunks and land. I used a cloth to wipe back the light areas in the water, leaving the reflection shape. I used a bristle brush to lightly scrub in the cloud shape.

What is
GLAZING?

A *glaze* is a layer of transparent paint applied over a lighter, dry color previously applied to the canvas. Watercolor artists often work with glazes, building transparent color over the existing paint to create a stained-glass effect. Oil painters can use this same technique. Glazing enhances the light. The light goes through the transparent paint and bounces off the opaque paint or gesso underneath.

Q **Why glaze?**

A Glazing a painting will deepen its color while allowing the other layers to show through the top layer. It can also be used to gray a color that is too bright or out of harmony with the rest of the painting. It can add depth to the painting, or create more luminosity. You can also change a color by glazing another color over it. For instance, you could glaze a blue over a yellow to make a green. You can glaze small areas or the whole painting.

Q **What paint should I use for glazing?**

A Transparent paints work best for this process because they require less medium. If you were to use an opaque paint thinned down with enough medium to create a glaze you would get a pool of medium with very little color. Some of the colors that work beautifully are the transparent oxides, the quinacridones, Cobalt Blue and Cobalt Violet. Perylene Red, Quinacridone Rose and Alizarin Permanent are beautiful reds for glazing. Test your pigments to determine the best color. If you will be using glazes as part of your normal working method, you may want to make a color chart (see page 126).

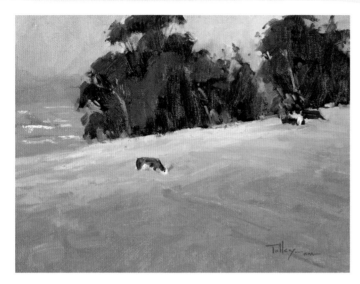

Before glazing

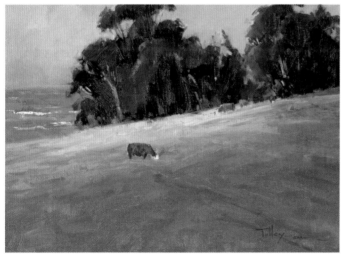

After glazing

ADD WARMTH AND ENRICH COLORS WITH GLAZING

I glazed the trees and land with 1 part alkyd medium thinned with 1 part OMS and a mixture of Quinacridone Rose, Cobalt Violet and a touch of Transparent Red Oxide. Notice how the glaze neutralized and deepened the greens. Before the warm glaze dried, I added more cattle with opaque paint.

What is
SCUMBLING?

Scumbling is the technique of applying a thin, light semiopaque layer of paint over a darker layer. It is best to scumble over a dry painting that has been re-wet with 2 parts alkyd medium and 1 part OMS. The surface has to be tacky enough for the scumbled layer to adhere, but not so wet that the scumbled layer simply mixes with the initial layer.

Scumbling can lighten a value or modify a color. Zinc White is semitransparent and is the best white to create this effect. Add some Zinc White to your glaze and brush it over the moistened surface. Apply it to your painting with a soft brush.

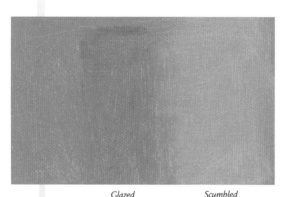

Glazed *Scumbled*

GLAZING VS. SCUMBLING AND DRYBRUSHING
Here Transparent Yellow paint was applied over a blue underpainting. Notice the scumbled area is lighter than the glazed area because I added Zinc White to the mixture.

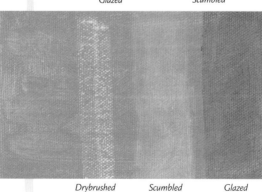

Drybrushed *Scumbled* *Glazed*

DRYBRUSHING, SCUMBLING AND GLAZING
Here Quinacridone Rose was applied over a blue underpainting by drybrushing, scumbling and glazing. For drybrushing use Quinacridone Rose and Titanium White. For scumbling use Quinacridone Rose, Zinc White and medium. For glazing use Quinacridone Rose and medium.

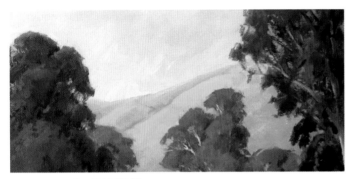

PREPARE THE DRY PAINTING

Re-wet the painting with a mixture of 2 parts alkyd medium and 1 part OMS. Use a soft brush to apply the mixture lightly, but do cover the area evenly. This will make the paint look fresh and will allow the new paint to adhere to the existing layer.

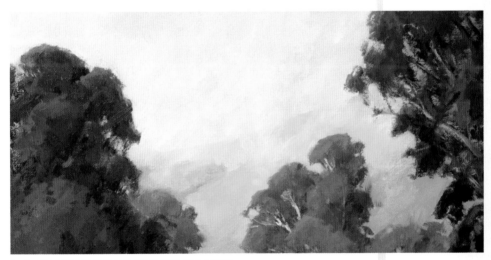

BRING THE SKY'S COLORS INTO THE PAINTING

Here I made a warm tint of Cadmium Yellow Deep, Cadmium Orange and Titanium White and a cool tint of Ultramarine Blue, Cadmium Red and Titanium White. I then scumbled the paint over the previously dry painting, applying the warm tints to the lighter areas of the mountain that are close to the sky and the cool tints to the darker areas close to the ground. Since the tints are semiopaque, parts of the mountain still show through.

How do I make
my OILS GLOW?

Oil painters have the ability to build glowing paintings. Glazing can create a rich glow. Another way is to let some of your transparent underpainting show through.

Oils are luminous by nature. When paint is applied thickly, the light bouncing off it creates a beautiful glow. To achieve glowing light with opaque paint, mix your colors and choose your values carefully so the colors glow by harmony and contrast.

A combination of transparent and opaque paints can create a beautiful painting. You will have light bouncing off the opaque passages and a glow from the transparent paint where the light comes through. (This effect is especially nice when painting trees.)

Luminosity can be achieved by the way you handle your paint as well as by the way you choose your colors and values. Laying your paint down instead of pushing it into the canvas will help to keep your colors luminous. The paint will sit up on the canvas and catch light. Overmixing an area or painting into an area that is partially dry and sticky can reduce luminosity. Fresh paint and a light hand with the brush go a long way toward creating a luminous surface.

Tips for Achieving Glowing Oils

- Try to avoid overmixing your colors on the palette. Let some of the mixes remain slightly unblended so that there are "sparks" of color in the mixture.
- Use a light hand to apply paint. Scrubbing paint onto the canvas will overblend the color with any paint already on the canvas.
- Mix only a few pigments to match a color you see in your landscape. The more colors you add, the less intense your results will be.
- Mix colors of the appropriate temperature to get a true color mixture (see page 96).
- Tonal value and color temperature are more important than an exact color match. If you get these two right, the color will most likely work without further refinement (and loss of intensity).

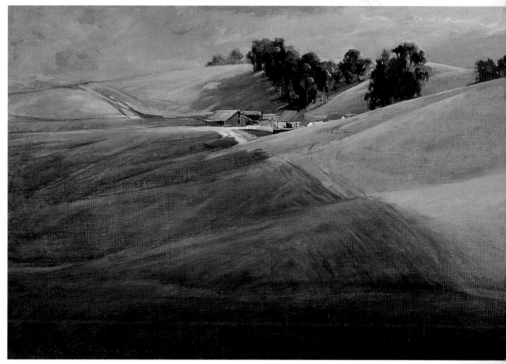

A WARM UNDERPAINTING AND A LIGHT HAND MAKES A PAINTING GLOW

This painting is an example of an indirect painting, a technique that relies on various layers of transparent and opaque paint. I lightly applied the foreground paint over a warm, toned canvas, letting the warm red earth glow through the green fields. I applied the paint more opaquely in the background hills, laying the paint down with a light hand and relying on color to create a luminous surface.

Evening Grace
Oil on linen on board
24" × 36" (61cm × 91cm)
Private collection

How do I create DEPTH *in my* PAINTINGS?

Artists use several techniques to create a strong illusion of depth in a painting. *Perspective,* both *linear* and *atmospheric,* is the principle way to do this.

Other ways to increase the illusion of depth include:

* **Overlapping shapes**. Overlapping shapes in the composition creates the illusion that foreground shapes are in front of midground shapes, and midground shapes are in front of background shapes. Think of your composition in terms of planes. Closer planes should be in front of more distant planes.

* **Diminution**. Objects of the same actual size appear to diminish in size as the distance from you increases. For example, closer figures appear larger than more distant ones. Even clouds appear smaller when they are nearer the horizon and thus farther away.

* **Decreasing detail**. Nearby objects should have greater detail and more texture than more distant ones (but not so much as to compete with the center of interest, which should have the most and sharpest detail). Atmospheric perspective (see page 137) will eliminate some detail, but the eye naturally sees close-up objects in more detail.

* **Soft edges**. Distant objects should have softer edges and less contrast for the same reasons distant objects should have less detail and texture.

Q What is aerial perspective?

A *Atmospheric* (or *aerial*) perspective is the term used to describe the effects impurities in the atmosphere have on our ability to see objects in the distance. Because of moisture and particles in the air, colors become grayer and generally cooler and bluer as they recede. The edges become softer, less distinct and have less contrast. The effects of atmospheric perspective are most obvious on damp, misty days. When the air is clear and dry, you might notice darker, richer color in the distance.

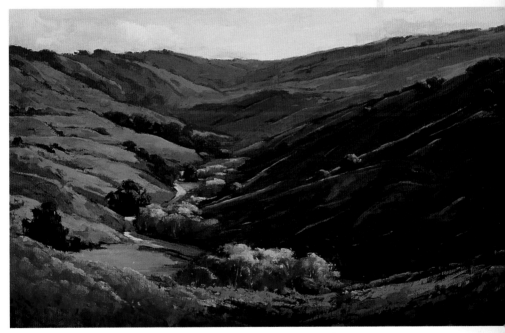

**COOL THE BACKGROUND TO CREATE
ATMOSPHERIC PERSPECTIVE**

Notice how the green changes from the warm, bright hue in the foreground to a gray-violet color as it recedes toward the background. The gradual change from the intense, pure colors and clear contrasts of the foreground to the cool colors and minimal detail of the background creates a convincing sense of depth.

Spring's Gift
Oil on linen on board
18" × 30" (46cm × 76cm)
Collection of Margaret & Keith Evans

Q What is linear perspective?

A *Linear perspective* is the technique of using converging lines to make objects appear to recede in space. The most important concept to understand about linear perspective is the relationship of your eye level with the horizon. Unless you are looking at a large body of water or a great expanse of level ground, the actual horizon is not visible. But you can determine where it is nonetheless if you remember that the horizon is always at your eye level. If you hold a brush horizontally at arm's length exactly at your eye level, the brush will be aligned with the horizon line, whether the latter is visible or not.

Any receding lines parallel to ground level (the imaginary plane that you are standing on that reaches out to the horizon) will appear to converge on that horizon line. Receding lines below the horizon will appear to rise up toward the horizon line or your eye level. Receding lines above will appear to converge down toward the horizon line.

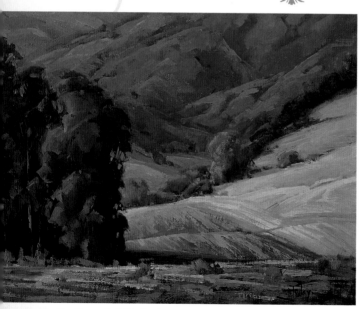

CREATING DISTANCE WITH OVERLAPPING SHAPES

Landscape painters also overlap shapes to show distance. As each layer of trees and hills overlaps each other, they appear to be farther away. This works especially well to establish distance when the air is clear.

Morning Breaking on the Valley Road
Oil on linen on board, 12" × 16" (30cm × 41cm), Private collection

How do I
PAINT WATER?

The first thing is to remember that you're seeing and painting shapes, value and color. Look very objectively at the colors of the water and paint what you actually see, not what you think water should look like. One technique for judging the accuracy of the colors of water is to look at the colors around the water, noticing the differences in tonal value and temperature. Assessing the color of water is easier when you compare it to the surrounding colors. Are the colors darker, lighter, cooler, browner or bluer? Studying your reference photographs of water is good training for judging shapes accurately. The most important part of painting water (or any shape in your painting) is to make sure the water relates to the composition as a whole by using repeated shapes and staying with the same color families.

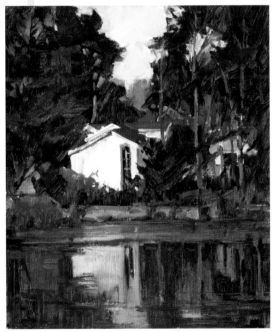

PAINT WHAT YOU SEE
In this *plein air* painting, I painted the reflections in the water as shapes, values and colors as I saw them.

Morning Reflections
Oil on linen on board, 12" × 10" (30cm × 25cm), Private collection

Q How do I paint reflections?

A Generally, reflections have different values than the objects creating them. Darks are usually reflected lighter and lights are reflected darker. The best time to paint reflections is in the quiet before a storm or in early morning, before the wind kicks up. On location, paint your water shapes first, then your shadow shapes before the wind comes up and the light changes. In the studio, you have the luxury of painting your reflections after you paint the shapes that create them.

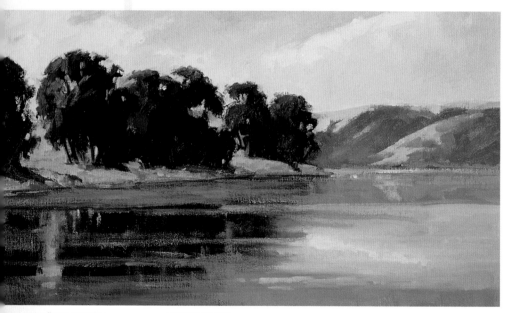

Mardi Gras Morning
Oil on linen on board
10" × 18" (25cm × 46cm)
Collection of John & Pam Flanders

REFLECTIONS

You have to work fast on location. Once I completed the water reflections, I painted the trees and shadows. As the wind came up, I dragged some of the wet color of the sky over the dark vertical reflections, capturing the wind breaking the surface of the water.

Q How do I paint still water?

A Still water that reflects almost like a mirror is a delight to paint because you don't have the extra challenge of painting ripples and waves, which refract and distort the objects the water reflects. As you paint reflections on still water, carefully compare the color and value to keep the water feeling and looking like water. Keep your edges soft as you change shapes and values. A bit of texture on the surface, such as a ripple, adds a nice contrast to the smooth stillness.

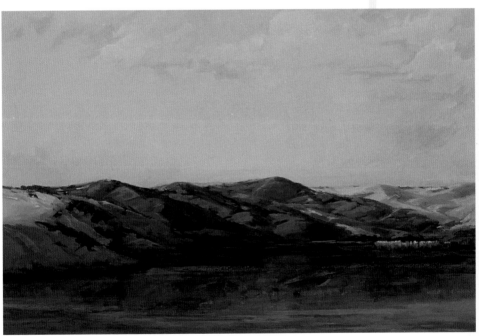

STILL WATER

Still water can be wonderful to paint because it creates a sense of quietness. When painting the reflections, look for softer edges, areas broken by wind or a current. Evaluate the color to see if the reflected color is grayer, cooler, darker or lighter than the objects reflected in the water.

Towards Evening, Back Bay
Oil on canvas
24" × 36" (61cm × 91cm)
Collection of the artist

Q How do I paint moving water?

 Moving water will reflect less because the surface is broken. Moving water is generally darker than still water because it does not reflect as much light sky. The waves also have value changes, and the areas hit by light will be lighter than the areas in shadow. Notice the wind patterns on lakes or bays. When looking at waterfalls or water rushing over rocks, notice how much of the rock color comes through the water. Paint that color and value. Remember to squint slightly to determine value and open your eyes to determine color.

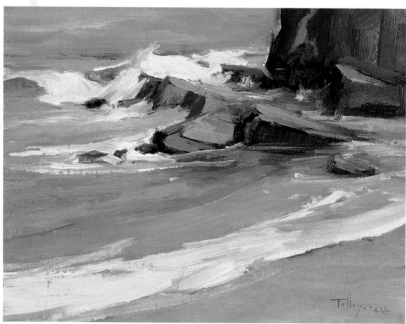

Spring Morning, Montana de Oro
Oil on linen on board
9" × 12" (23cm × 30cm)
Collection of the artist

MOVING WATER

In this plein air study, I wanted to capture the movement, colors and values of water. The dark, motionless rocks provide a nice contrast against the water's moving surface. Painting some water breaking on the rocks further illustrated the water's movement.

What Color Should I Paint Water?

In order to paint reflections, you need both a shape and color to work from. In the studio, you can paint the objects creating the reflections before you paint the water. The water's color and value should relate to what is around it.

MATERIALS

OILS

Titanium White, Cadmium Yellow Light, Cadmium Yellow Deep, Cadmium Orange, Cadmium Red Medium, Burnt Sienna, Alizarin Permanent, Ultramarine Blue, Cobalt Blue, Viridian, Chromatic Black

MIXTURES

Grays made with Cadmium Red Medium and Viridian, lightened with different amounts of Titanium White for a range of values

SURFACE

Linen primed for oil painting

BRUSHES

Nos. 4 and 6 hog-bristle filberts; nos. 6 and 8 sable filberts

OTHER

1-inch (25mm) palette knife, alkyd medium, odorless mineral spirits, rag

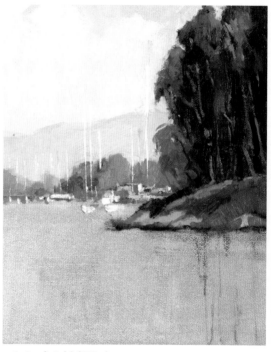

1 **Apply Initial Washes**
Tone the area of the canvas where the water will be with Burnt Sienna and Cobalt Blue using a rag or a no. 6 filbert.

2 Add the Vertical Areas

Lay down a base where you will paint the trees' dark reflections. With a small amount of alkyd medium, lay in a transparent wash of Burnt Sienna and Cobalt Blue. The wash should have an approximate value of 6. Over the base, start to paint the reflections in the water with vertical strokes over the underpainting. Using your premixed grays, choose the value that you need and paint the reflections of the land and boats. If necessary, add in more pure hue to the grays to maintain value and color harmony to objects they reflect.

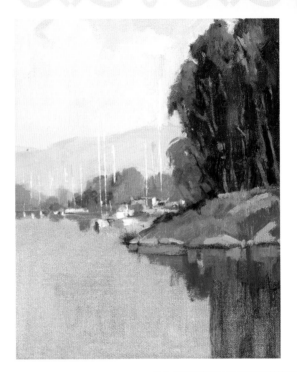

4 Build the Sky's Reflections

To represent the sky reflecting in the water, mix a darker, cooler value of your sky paint: Cobalt Blue, Cadmium Orange, Cadmium Red Medium and Titanium White. Apply the paint thinly to the water.

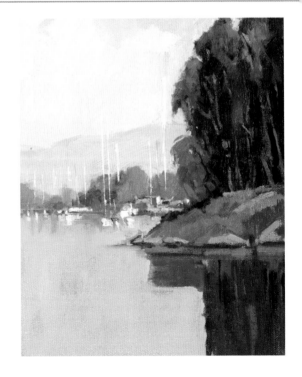

3 Build the Dark Reflections

Keep building the reflections with the grays, leaving the edges alone at this time. You will blend or soften them later while the paint is still wet. Add shadows and reflections to the boats with a middle-value cool gray and a no. 4 filbert. As the painting proceeds you will adjust the shadows.

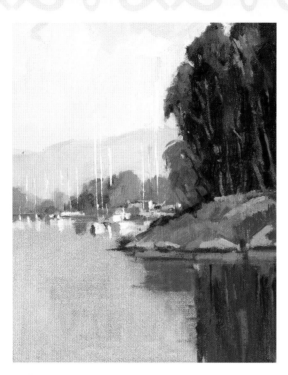

5 Add the Light Verticals for the Masts

Paint the masts with Titanium White using a no. 6 sable filbert. Since you are adding the Titanium White to wet paint, the white will lose some of its purity as it merges with the surrounding colors. Add a cool gray that's a little darker than the sky to the distant water by the boats.

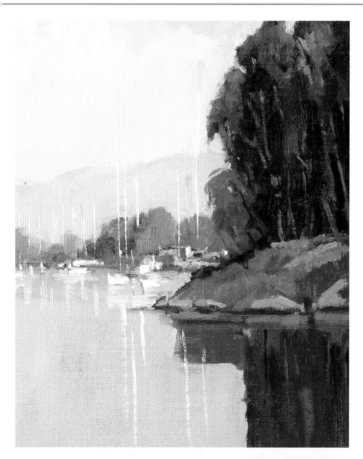

145

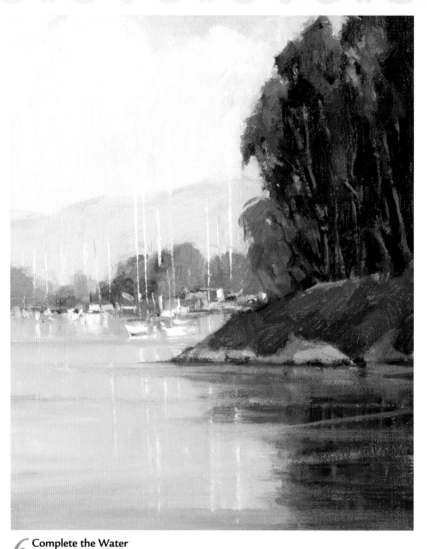

6 Complete the Water

Working around the sailboats, add some of the mountain and sky color (grays made with Cadmium Red Medium, Ultramarine Blue and Titanium White) to the water with vertical strokes. Darken the paint a bit with Ultramarine Blue and add horizontal marks on the water where the wind breaks the surface. Take your largest hog-bristle or sable filbert and pull the wet paint lightly across the darker reflections to soften them.

Darken a few areas around the tree branches to complete the land. The bluff's value was too light, so darken by scraping up the paint with a palette knife and painting on a darker value made from the trees's greens: Alizarin Permanent, Cobalt Blue, Cadmium Yellow Light, Cadmium Yellow Deep and Chromatic Black. Now the values in the trees, land and water connect better and the painting is done.

How do I paint GRASSES, SHRUBS and FLOWERS?

Knowing how to paint grasses is important for a landscape painter because grasses are part of many landscape scenes. Often the foreground can be intimidating if you don't have a good design or shape to work within, or a knowledge of how to paint the textures. The trick is to move the brush in the same direction the grasses, flowers or shrubs grow.

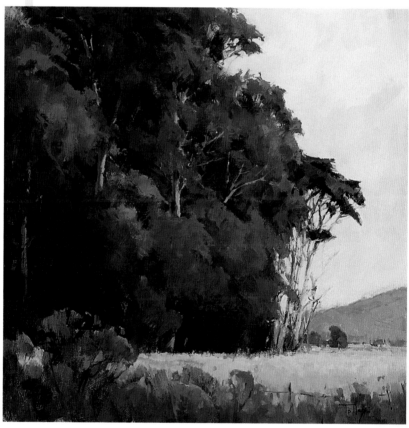

USE GRASSES TO PROVIDE CONTRAST
Here the grass repeats the verticals of the trees and provides a nice contrast to the yellow field. I painted the foreground shrubs with a filbert and a light hand, turning the brush to use both the flat side and the edge. My loaded brush danced lightly over the surface, leaving beautiful marks that represent foliage.

A Fine Day
Oil on linen on board
16" × 16" (41cm × 41cm)
Collection of Ann Martel & Jim Corley

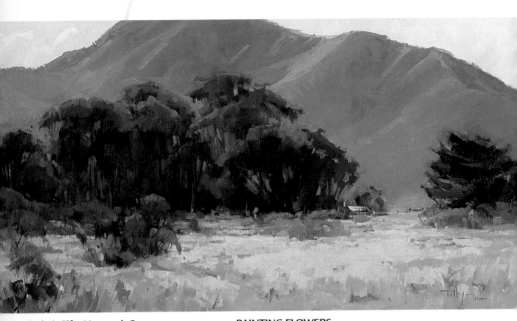

Spring's Gifts, Montana de Oro
Oil on linen on board
12" × 24" (30cm × 61cm)
Collection of Katherine Smith

PAINTING FLOWERS

To paint this field of wildflowers, I kept the color intense and the brushwork vertical and active in the foreground. To make the flowers and grasses in the middle ground recede, I grayed the color with Titanium White and used less active brushwork. The blue-violet makes a nice contrast with the warm field and helps pull the eye back into the painting.

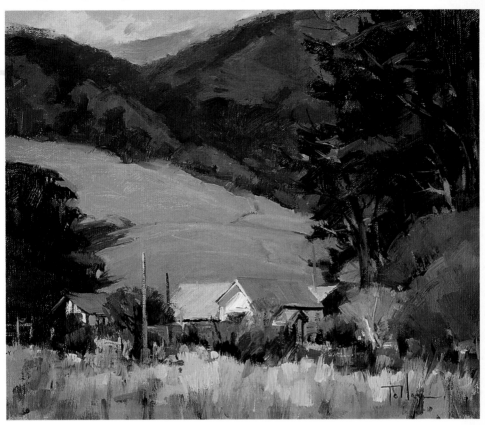

PAINTING GRASS

By maintaining correct values in textured areas, you can create a solid pattern that suggests untended, wild grass. The solid pattern doesn't distract from the buildings, which are the painting's focal point.

Sunny Sunday
Oil on linen on board
10" × 12" (25cm × 30cm)
Collection of Bonnie Moton & Michael Molen

DETAIL OF THE GRASS TEXTURE

How Do I Paint Trees?

Before you start to paint a tree, consider its basic shape. Does the shape have enough action and movement to make it interesting? You can make a tree shape more engaging by avoiding extreme symmetry and by having some of the sky peek through the tree so it doesn't look like a solid mass. Add movement by giving the shape some direction by elongating one side and giving the trunk a diagonal thrust.

Also, consider the direction of the light. Keep the shadow areas darker and more transparent. If the light is warm, the shadows will be cool. The areas in light should then be painted with more opaque warm colors. One more thing to consider as you look at the trees: Where does the light break the form? This is where you will need to create lost edges.

MATERIALS

OILS

Cadmium Yellow Light, Transparent Yellow Oxide, Cadmium Orange, Cadmium Red Medium, Transparent Red Oxide, Quinacridone Rose, Ultramarine Blue, Cobalt Blue, Viridian, Sap Green, Titanium White, Ivory Black

MIXTURES

Cool gray made with Ultramarine Blue and Cadmium Orange (values 4 and 6)

Warm gray made with Viridian, Quinacridone Rose and Cadmium Red Medium (values 4 and 6)

SURFACE

Linen primed for oil and taped to a Masonite board

BRUSHES

Nos. 4 and 6 hog-bristle filberts

OTHER

2 parts alkyd medium mixed with 1 part odorless mineral spirits

1 Create an Underpainting of Basic Shapes

Use the no. 6 filbert to paint the tree's silhouette with Transparent Yellow Oxide, Transparent Red Oxide and Viridian thinned with alkyd medium. Apply a wash of Transparent Yellow Oxide and Quinacridone Rose with the no. 6 filbert to the land. Mix some Cobalt Blue with some Quinacridone Rose and apply it to the background hill. Apply a light wash of Transparent Red Oxide and Transparent Yellow Oxide to create the sky. Let the paint dry enough to be tacky.

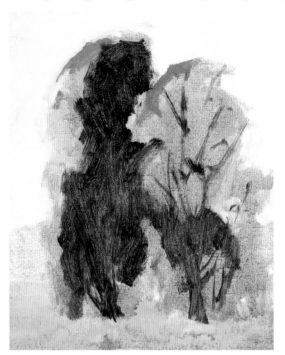

2 Add Darks to the Trees

With the no. 4 filbert, draw trunks in the trees with Transparent Red Oxide to establish the way the trees are leaning. Build richer color using transparent washes on the shadow sides of the trees with a mixture of Ultramarine Blue and Transparent Yellow Oxide. Paint over and around the trunks. Add thin layer of Transparent Yellow Oxide and Cadmium Orange where the light is striking the tree. Now you have distinguished the highlighted areas from the shadows.

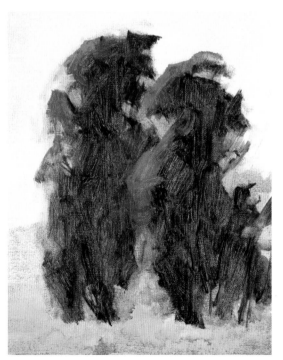

3 Build the Trees' Shapes

Continue to build the trees' shapes with a no. 4 filbert, staying transparent in the areas that will not be in strong light. Keep the darks transparent but make the lights and middle values more opaque. Add Cadmium Yellow Light to the yellow-orange mixture on your palette from step 2, then add a little Sap Green to create a warm green. Paint this next to the warm light areas.

4 Add Volume to the Trees and Put in the Background

Here you'll add opacity and volume to the trees' shape. Add a dark, cool gray to the tree mixture creating a cooler green for the areas in shadow. Where the light is mostly blocked, add darker cool grays to the mixture. Add some dark warm grays where some warms poke though the trees. Let some of the transparent underpainting show through these new paint layers.

Lay a thin layer of paint on the sky using a mixture of Titanium White, Cadmium Yellow Light and Cadmium Orange. Paint the background hill with a thin layer of the lighter warm gray.

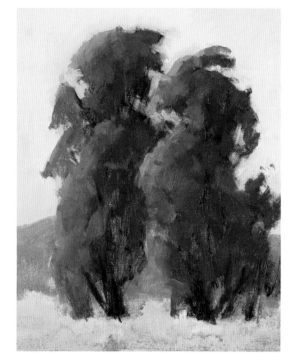

5 Paint the Sky and Background

Paint the sky with another layer of the sky mixture from the previous step, this time painting into the edges of the trees' silhouette. Add a bit of Cadmium Orange to the sky mixture to create a darker, cooler value. If that is too warm, add a bit of Cadmium Red Medium. If the mixture is too bright, add a touch of the green from the tree to tone it down. Paint in areas where the sky shows through the trees.

Add white to the middle light cool gray and paint over the background hill, letting some of the violet mix in and show through the loose brushstrokes. Add some darker transparent warm values of Transparent Yellow Oxide, Quinacridone Rose and Cobalt Blue to the foreground grasses.

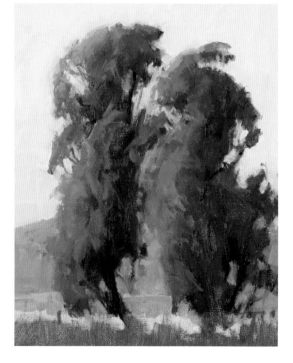

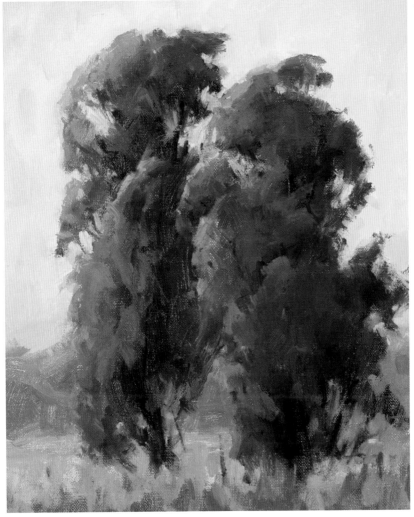

6 Add the Finishing Touches

Add the cool middle dark gray between the trees to separate them. Soften the edges of the trees with a clean brush by pulling some of the sky's color into the trees and some of the trees' color into the sky.

Mix a light, grayish yellow-orange from your early paint puddles. Add Titanium White if you need to lighten, or add dark violet-gray if you need to darken. Create the foreground grasses with vertical brush marks using your no. 4 filbert. As you move back, subdue your brushstrokes and change to a green by adding Viridian and Titanium White with a touch of Cadmium Yellow Light and then change to a grayed violet-orange made with Cadmium Orange, Permanent Rose and a touch of the light violet gray.

When should I
INCLUDE FIGURES?

Painting figures in your landscape can add a bit of color and can be great for showing scale. The figure should appear to be a part of the painting, not an afterthought. Figures attract attention because they are natural centers of interest, so unless you intend the figures to be focal points that attract the eye, let the figures blend in with the colors around them. Minimize detail, hard edges and color contrast so the figures support the focal point.

Make sure you know how to draw and paint the figures' shapes. The silhouette is the most important feature to get right. Viewers have the ability to identify figures very quickly by their overall shape. A figure seen from the front or back is more easily identified than from the side, and from the side more easily when the limbs are not too close to the body. Practice making figures with leftover paint and scrap canvas.

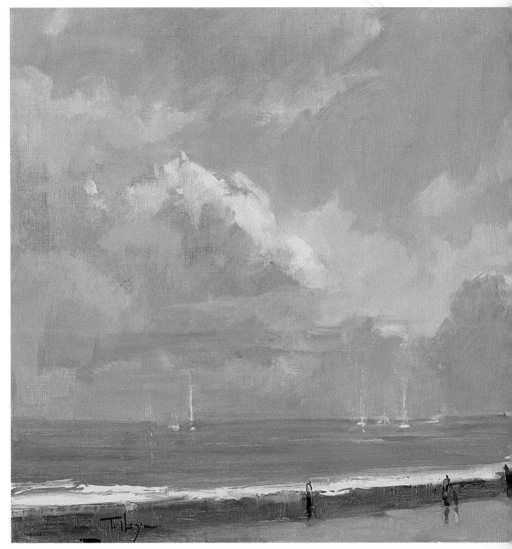

FIGURES CAN SERVE MULTIPLE FUNCTIONS

I used the figures in this painting to do several things: suggest scale for the scene, add complementary color and contrasting temperature, and to establish verticals that are echoed by the sailboats.

Summer Morning Clouds
Oil on linen on board
12" × 12" (30cm × 30cm)
Collection of Gary & Pandora Karner

When should I
ADD ANIMALS?

When you want to show scale, add color, contrast or variety, or define the mood in a painting, adding animals can be the solution. Including animals in a pastoral scene also helps describe the setting because they suggest that the land is rich and productive.

When you decide to include animals, use reference material to get the shapes correct. Remember to diminish the size of animals farther back in the painting. Watch your spacing so the animals appear at interesting intervals. Try to group animals to create one connected shape.

Practice drawing cattle, sheep, horses and goats. Get to know the way they stand and move so you can paint them with more confidence.

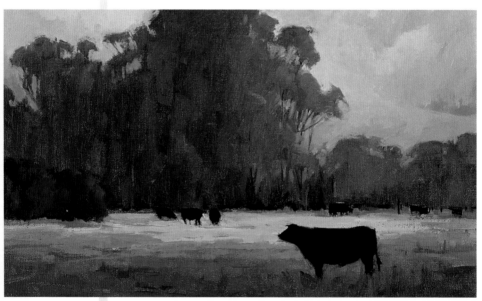

Lifting Fog, Torro Creek
Oil on linen on board
12" × 22" (30cm × 56cm)
Private collection

ANIMAL FIGURES CAN ADD MOVEMENT TO A QUIET PAINTING
The foreground cow is used to establish a shape that is repeated in the middle ground. This arrangement creates diagonal action lines in an otherwise quiet composition.

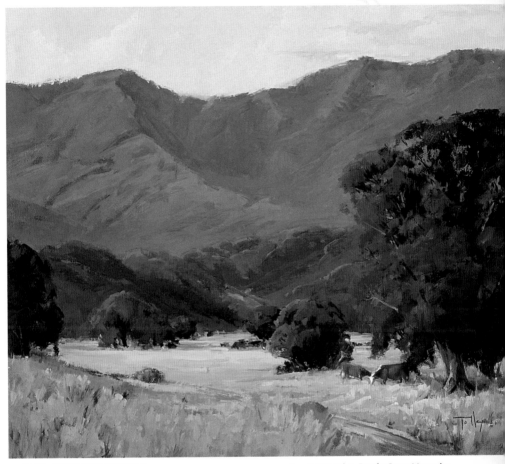

ANIMAL CAN PROVIDE SCALE

The cattle in this painting give a sense of scale and add touches of color. I also used them to add to the pastoral feeling by keeping their shapes quiet. "Quiet" shapes are simple shapes with no eye-catching complexity or thrusts that suggest movement or imbalance.

Summer Morning, Rancho Santa Margarita
Oil on linen on board
20" × 24" (51cm × 61cm)
Collection of Janet Evander & Mark Wimer

How Can I Add Interest With Animals?

The figures in this landscape add contrasts in color, shape and size. Without the cattle, the tree would still be a lovely poetic shape, but the cattle add interest and certainly reinforce the pastoral feeling.

MATERIALS

OILS

Cadmium Yellow Light, Cadmium Yellow Deep, Raw Sienna, Cadmium Red Light, Alizarin Permanent, Cobalt Blue, Chromatic Black, Titanium White

SURFACE

Linen primed for oil

BRUSHES

No. 2 hog-bristle bright, nos. 4 and 6 hog-bristle filbert

OTHER

1 part alkyd medium thinned with 2 parts odorless mineral spirits, lint-free cloth

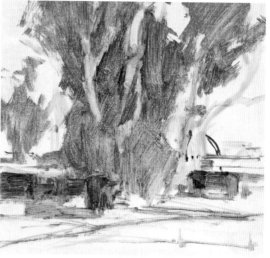

1 Block In the Basic Shapes

On a canvas stained with Alizarin Permanent and Raw Sienna, lay down the basic shapes with a thin mixture of Cadmium Yellow Light, Cobalt Blue and a touch of Alizarin Permanent. For the darker shapes, apply a mixture of Alizarin Permanent and Chromatic Black. Notice the action line running diagonally through the foreground.

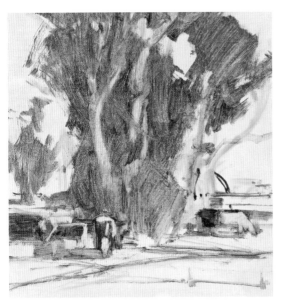

2 Wipe Out the Lights

With a cloth or wet brush, wipe out the light areas of the figures. You can see the painting taking shape. Adjust the placement of any shapes if necessary.

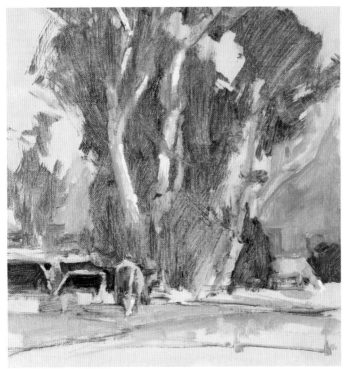

3 Develop the Cattle's Forms

Build up the forms of the cattle with a thin layer of paint. Let bits of the underpainting show through. At this stage, it is still easy to add or change figures in the painting because there is not a lot of thick paint down. Lighten the tree trunk with Titanium White so it's lighter than the front cow.

4 Complete the Painting

Paint the cattle with a mixture of Raw Sienna, Cobalt Blue and either Cadmium Red Light where the sunlight warms the coat, or Alizarin Permanent where the coat is in shadow. Use the cool red mixture in the shadow of the tree, and the warm red mix in the warm areas for unity. Paint the grasses using Cadmium Yellow Deep, Cadmium Yellow Light, Cobalt Blue and a touch of Cadmium Red Light. Pull the wet grasses up and over the cattle's legs and faces to integrate the cows into the composition and soften the edges. Create cool shadows on the land with the dark cool red mixture and some of the cool grass mixture.

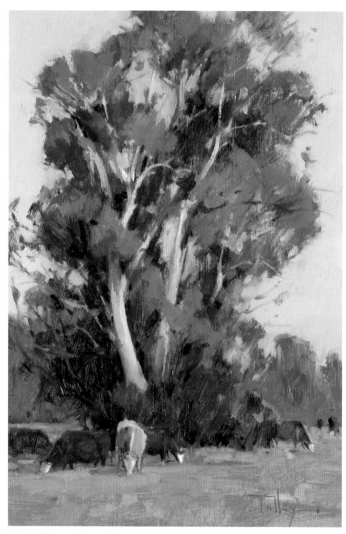

Winter Afternoon, Santa Barbara
Oil on linen, 12 " × 8 " (30cm × 20cm), Collection of the artist

What can BUILDINGS achieve in a LANDSCAPE?

Landscape painters use buildings in paintings to describe a place, show scale, offer a bit of color or indicate human presence. Sometimes you may want the painting to focus on the structure, other times you will want the building to support the landscape, depending on what idea you want to express. A building or structure is a natural center of interest, so if you want the viewer to focus on some other aspect of the scene, the building must be painted with subtle colors, values that don't contrast with the surrounding ones and no sharp or pronounced details and textures.

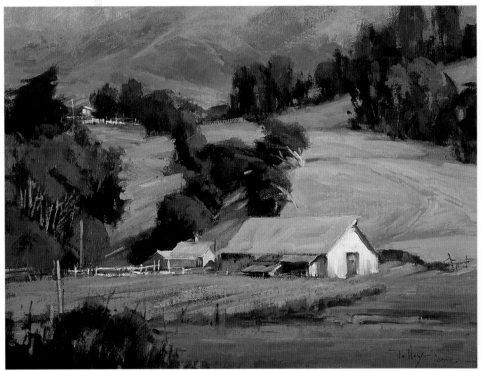

USE BUILDINGS TO INDICATE SCALE
I diminished the scale of these buildings to show more of their environment. The buildings on the hill draw the viewer into the painting as they repeat the shapes of the bright foreground buildings.

Summer Evening on the La Familia
Oil on linen over board
12" × 16" (30cm × 41cm)
Private collection

Buildings often look too large when they are rendered on canvas. If this is the case with your painting, check your sketchbook to see if the buildings looked large in the sketch or if they grew with too much paint. It is easy to overlook this problem when in the throes of painting, especially on location. Remember, however, that it's up to you to decide what is important to your painting. By changing the size of your buildings you can alter the way the landscape feels. The smaller the buildings, the larger the land looks, and vice versa. Don't be afraid to use artistic license.

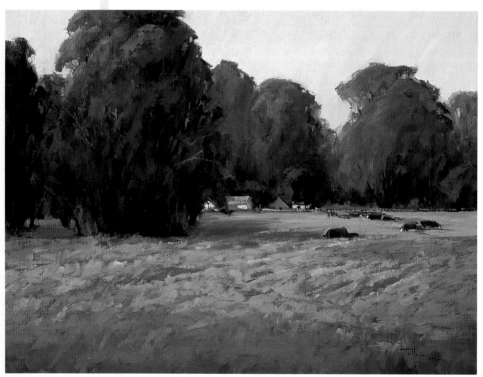

In the Warmth of the Evening Sun
Oil on linen on board
18" × 24" (46cm × 61cm)
Collection of Loren Johnson

BUILDINGS CAN ADD DASHES OF COLOR TO THE EARTH TONES OF A LANDSCAPE

The cattle create a line leading the viewer's eyes into this painting, while the buildings are little more than dashes of color that add a bit of visual interest, provide scale and suggest a human presence on the land.

REPEATED SHAPES WITHIN BUILDINGS ADD MOVEMENT AND UNITY

It is not necessary to paint the whole building to express a thought. By cropping this building, I kept the thought simple. The repeated diagonal lines provide paths for the viewer's eye, and the rectangular shapes help to unify the composition. The flowers add just enough detail to suggest a garden.

Come in the Back
Oil on linen on board
12" × 12" (30cm × 30cm)
Collection of Arthur Ermish

How Do I Paint Buildings?

Small quick sketches like this allow you to work out color harmonies and explore size relationships. What looks good on location might not work as well in a painting. After I did this sketch, I decided that the foreground bushes would really be distracting in a larger painting. They would have to be redesigned. The building size and color work really well, however.

MATERIALS

OILS

Cadmium Yellow Light, Cadmium Orange, Cadmium Red Light, Transparent Red Oxide, Ultramarine Blue, Viridian, Titanium White

MIXTURES

Cool grays made with Cadmium Orange, Ultramarine Blue and Titanium White (values 4, 6 and 8)

Warm green made with Cadmium Yellow Light, Cadmium Red Light and Viridian

Cool green made with cool gray mixture (value 4), Cadmium Yellow Light and Viridian

SURFACE

Linen primed for oil

BRUSHES

No. 2 bristle bright; nos. 4, 6 and 8 hog-bristle filberts; nos. 4, 6 and 8 hog-bristle flats

OTHER

2 parts alkyd medium mixed with 1 part odorless mineral spirits, rag

1 Block In Transparent Shapes
On a canvas stained with Transparent Red Oxide, build the base shapes with Transparent Red Oxide, Viridian and Cadmium Red Light. Wipe back the light shapes on the buildings with a rag. This will leave a nice warm undertone for the lighter opaque layer.

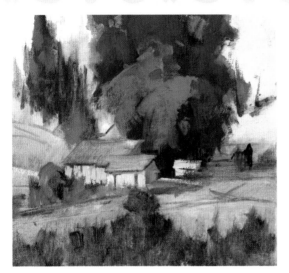

2 Build the Forms

With your lighter paint mixtures, start to build the forms of the buildings and the trees. The light is a cool morning light, so the light values will have more white in them than if this were an evening painting. Painting cool light over a warm underpainting creates a nice vibration. To build up the paint in the foliage, make warm and cool greens as you paint the buildings, paint the foliage, letting the building and the trees develop together

3 Complete the Sketch

Continue to build the forms with paint. As you build the trees and land, take some of the sky color (Cadmium Red Light, Ultramarine Blue, Titanium White and a little Cadmium Orange) into the roof of the barns. Pull some of the warm color from the land into the light sides of the barns to integrate them. Make some edges hard and lose others where you want to create a passage such as where the large barn's shadow side merges with the tree.

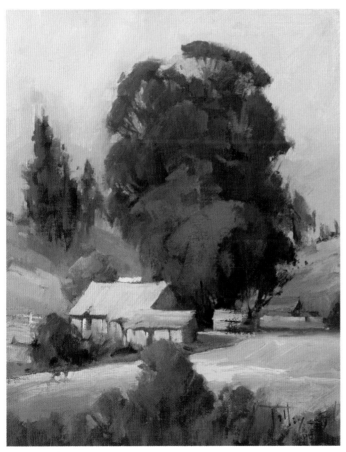

One Last Look
Oil on linen on board, 10" × 8" (25cm × 20cm), Collection of the artist

What can CLOUDS do for MY PAINTINGS?

Clouds add a considerable amount of interest in a landscape painting. Clouds can suggest the time of day and the state of the weather, factors that influence the overall mood expressed in the painting. Dark clouds may suggest threatening weather and create an uneasy mood or they might suggest a quiet, somber mood. White clouds suggest bright midday and impart a lighter mood. Pink or yellow clouds suggest a rising or setting sun and the moods associated with those times of day.

The colors and shapes of clouds also play an important compositional role in your painting. They contribute to the dominant temperature, tonal value and directional thrust. When painting clouds, include a variety of sizes and shapes. Try to connect smaller shapes to create larger forms.

Clouds can balance the visual energy in a composition. A landscape busy with a lot of shapes, colors and textures in the foreground can be offset by a sky with soft-edged clouds. In order

CLOUDS CAN CREATE COLOR HARMONY
Staying in the same color family creates unity, so I repeated the color of the clouds in the rocks and buildings. While the clouds at their lightest appear white, the white is actually a tint made from a mixture of Titanium White, Cadmium Orange and Cadmium Yellow Deep.

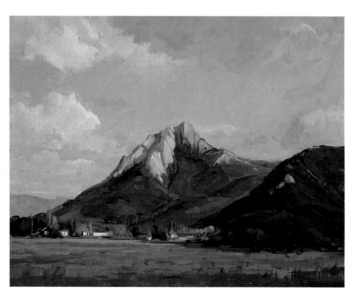

Spring, Hollister Peak
Oil on linen, 16" × 20" (41cm × 51cm), Collection of Gayle & George Rosenberger

to paint a sky and clouds that will harmonize with the rest of the composition, consider what their purpose is: ask yourself if they are the main feature or if they are supporting the land.

To understand clouds and the way they move, set up your easel near a window and paint cloud studies from life. It is wonderful practice.

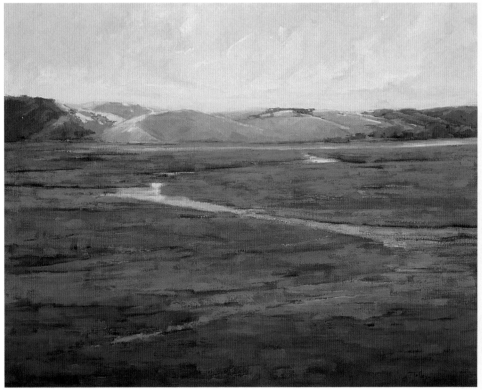

CLOUDS CAN CREATE UNITY
The light on the dunes subtlety direct the eye upward while the light in the water forms a diagonal path that connects with the light in the sky. To paint the clouds, I made tints of white with all the warm colors on my palette in values 8 and 6. To paint the cooler violets in the clouds, I used the violet-grays from the dunes, lightening them to the appropriate value. I painted these colors into the cloud shapes to unite the land and sky.

Afternoon Glow
Oil on linen
24" × 30" (61cm × 76cm)
Collection of John & Jody Nakashima

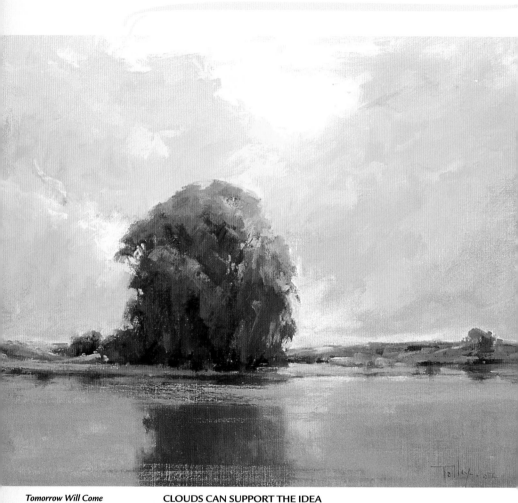

Tomorrow Will Come
Oil on linen
14" × 18" (36cm × 46cm)
Collection of Gail Spiegel

CLOUDS CAN SUPPORT THE IDEA

This piece began as different reference paintings that I combined to create a personal statement. The color, light direction and design of the clouds support the tree, which is the center of interest. I painted the clouds with mixtures of the transparent reds I used in the tree, adding Titanium White, Cadmium Yellow Deep, Cadmium Orange and Cadmium Red Light to create more opacity.

I painted the large shapes first, then added the lighter, warmer areas on top of the wet paint. I created the warm blue of the sky at the same time, blending and softening the edges while the paint was wet.

168

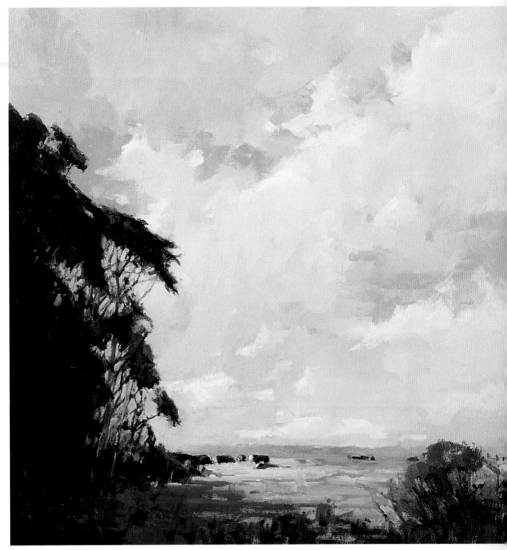

CLOUDS CAN ENHANCE THE MOOD

These clouds suggest movement, enhancing the expansiveness of this landscape. I kept the focus on the tree and cattle by connecting the cloud shapes and limiting their value range.

Moment in the Sun
Oil on linen on board
20" × 20" (51cm × 51cm)
Collection of Will & Elaine Bateman

How Do I Paint Clouds?

The most common color associated with clouds is white. However, if you start with white, you will not be able to add highlights or create warmth. Lower the key of your clouds so that you will be able to add lighter areas to suggest sunlight. Start your clouds with light, colorful grays (see page 110), perhaps a value 6 or 7. Once these are blocked in, add lighter values for the clouds in light, and darker values for those in shadow. Consider contrasting the color temperature of the areas in light with that of the dark areas so you can emphasize the quality of light (just make sure one temperature is dominant). Warm lights and cool shadows will suggest late afternoon sunlight. Cool lights and warm shadows will suggest late morning or midday.

MATERIALS

OILS
Titanium White, Cadmium Yellow Deep, Cadmium Orange, Cadmium Red Medium, Ultramarine Blue, Cobalt Blue, Viridian

MIXTURES
Cool gray made with Ultramarine Blue, Cadmium Orange and Titanium White (Ultramarine Blue dominant)

Warm gray made with Cadmium Orange, Ultramarine Blue and Titanium White (Cadmium Orange dominant)

SURFACE
Linen primed for oil

BRUSHES
Nos. 6 and 8 hog-bristle flats or filberts

1 **Lay Down the Basic Shapes**
With a no. 8 flat or filbert, thinly paint the basic shape of the clouds. Make the first layer darker than the finished painting so that you can add lighter values later. Apply a cool gray to the shadow sides of the clouds. This establishes the clouds. For the areas in light, tone the white canvas with Cadmium Orange mixed with the light warm gray to establish a warm glow. With a mixture of Cobalt Blue, Viridian and a small amount of the warm gray mixture, paint around the cloud shapes for the sky.

2 Build Up the Paint Surface

Add a thicker mixture of Cadmium Yellow Deep and Titanium White to the clouds' light area. Continue to build the shape of the clouds with the warm and cool grays. For interest and temperature variation, apply a warm gray over the cool gray. Lay in a halftone of sky color and cloud white between the lightest light and the blue of the sky.

3 Adjust the Shapes and Work the Edges

To create the wispy look of the clouds, pull the color of the sky into the cloud shape with your brush. Add a darker cool gray where you want to show shadow. If your grays seem too neutral, add some of the sky color. If you need more violet or a redder warm orange, add some Cadmium Red Medium to the clouds. This will tie the sky to the land. Paint in the sky color where you want to suggest thinner clouds. Keep the edges soft.

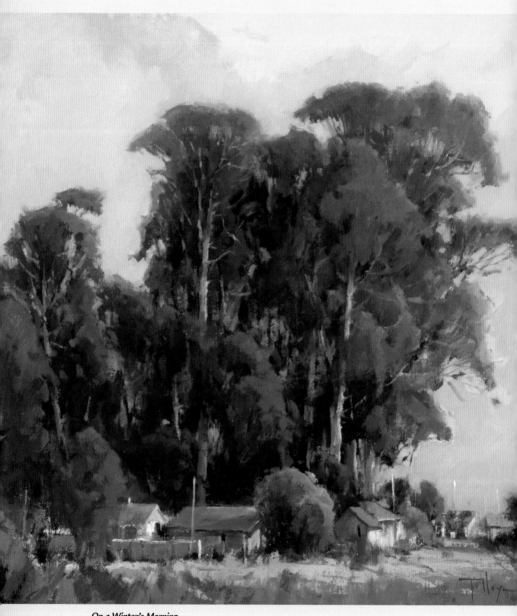

On a Winter's Morning
Oil on linen on board
16" × 16" (41cm × 41cm)
Collection of the artist

6

DEMONSTRATIONS

The following demonstrations show the process I use to take a small sketch or painting to a larger, more complex studio painting. These examples cover different seasonal and lighting conditions. I use my reference photos, value studies, and small *plein air* paintings or sketches to help me organize and complete larger paintings.

You will find that larger paintings need more texture and decoration than smaller ones. What looked good small doesn't always translate as well to a larger canvas. Your reference photos can be a great help with geographical information, but they will not accurately represent the light or color. If you are working from reference photos only, I suggest you do a small color study before making a larger painting.

As your paintings increase in size, you will need more paint on your palette, larger brushes and a larger mixing area. The paintings in these demonstrations are done in medium-size formats. Often I will paint in a medium-size format before taking the painting to a large format. For instance, I might work from a 10" × 12" (25cm × 30cm) painting, taking it to a 20" × 24" (51cm × 61cm). After working in that range, if I still feel that I could go larger, I will be familiar with the subject as I redesign it for a larger canvas.

Summer Clouds Over Back Bay

This demonstration will show you how to make a painting with a full range of values. During this demonstration you will also adjust the overall value of the painting to have more value range in the clouds. The demonstration will use a plein air *painting as the reference.*

This painting is broken down into three major shapes: sky, land and water. The most activity will be in the land; the other two shapes will support that activity through movement and reflections. A base coat of warm gray will establish the values of the sky and clouds, and will neutralize the blue you will apply later to keep it from being too blue. The lighter and darker values laid over this base will establish the form of the clouds from the outset.

MATERIALS

OILS

Titanium White, Cadmium Yellow Light, Cadmium Yellow Deep, Transparent Yellow Oxide, Transparent Red Oxide, Cadmium Orange, Cadmium Red Light, Quinacridone Rose, Alizarin Permanent, Ultramarine Blue, Cobalt Blue, Viridian, Sap Green, Chromatic Black

MIXTURES

Grays made with Chromatic Black and Titanium White in values 1 (black) to 10 (white).

Greens made with:

Ultramarine Blue and Transparent Yellow Oxide. Make a warm green with more yellow and a cool green with more blue

Cobalt Blue and Transparent Yellow Oxide. Make a warm green with more yellow and a cool green with more blue

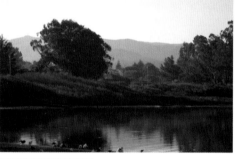

REFERENCE PHOTO

SURFACE

Linen primed for oil and painted with a light value warm gray (Titanium White Cadmium Red Light and Viridian) that has dried

BRUSHES

Nos. 4, 6 and 8 hog-bristle flats; nos. 4, 6 and 8 hog-bristle filberts; no. 2 bright

OTHER

2 parts alkyd medium thinned with 1 part odorless mineral spirits, lint-free rag, palette knife

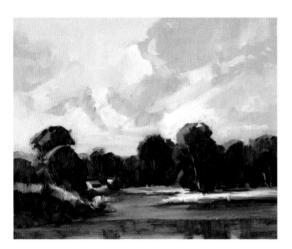

A Note About Brushes

During these demonstrations, different brushes will be used. If a brush is not specified, use the size that is most comfortable for you.

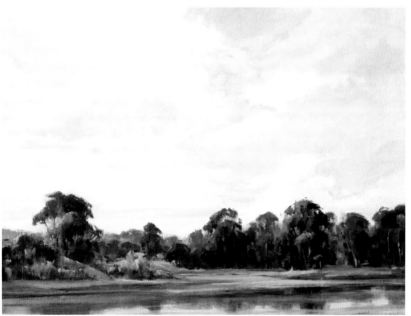

PLEIN AIR PAINTING

Clouds Over Sweet Springs
Oil on linen on board
18" × 24" (46cm × 61cm)
Private collection

1 Lay In the Large Shapes

Mix Ultramarine Blue with Titanium White and a touch of Cadmium Red Light. Gray the mixture with Chromatic Black. Apply a thin layer of this mixture to the sky. Create warm areas with the Cadmium Red Light grayed with Chromatic Black, Titanium White and a touch of Ultramarine Blue.

With Cadmium Red Light and a bit of Cobalt Blue, lightly sketch in the shapes of the land with the no. 2 bright. Lightly mark the verticals of the reflections.

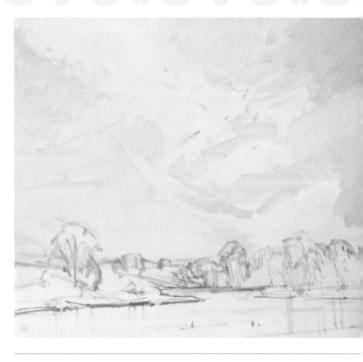

3 Continue to Develop the Trees and Land Shapes

To build up the trees, add Cadmium Yellow Light and Cadmium Yellow Deep to the transparent Cobalt Blue mixture from the water. Lighten with Titanium White if you need to. Apply this mixture to the areas in sunlight. On the shadow side start to deep the value with Ultramarine Blue, Transparent Yellow Oxide and a small amount of Titanium White, creating a touch of opacity over the transparent darks. For the lighter, cooler trees in the distance, use Cobalt Blue added to a middle value of your premixed grays and apply this to the background trees on the left. For variety, change the color from a blue-gray on the left to a green-gray for the trees on the right by adding some Viridian and Transparent Yellow Oxide to the middle-value gray. As you paint this shape, keep your brushstrokes less active. Start to build volume in the dark trees by mixing one of your blues into the warm opaque mixture you used for the areas in light. This value should be about a 5 and will be semiopaque. Lay this paint down lightly on the shadow sides of the trees.

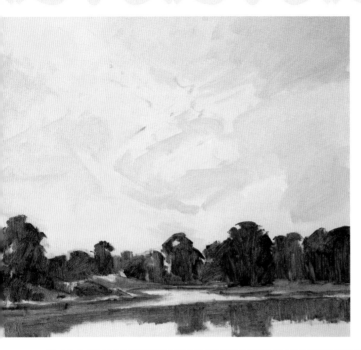

2 Establish the Darks and Lights, Warms and Cools

With Ultramarine Blue mixed with Transparent Yellow Oxide, lay in the shapes of the trees. Paint the shapes that are in the sun a warmer temperature than those in shadow. For the land, use Transparent Yellow Oxide warmed with Transparent Red Oxide and a touch of Quinacridone Rose. Build the reflections in the water with Cobalt Blue and Transparent Yellow Oxide.

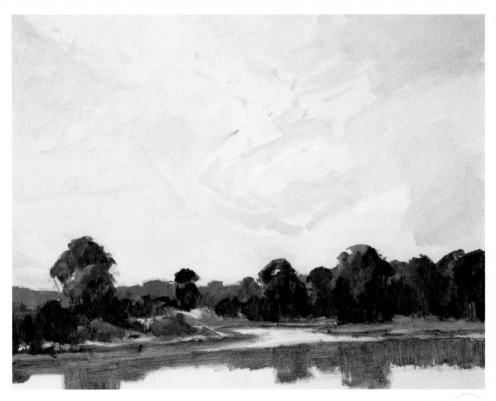

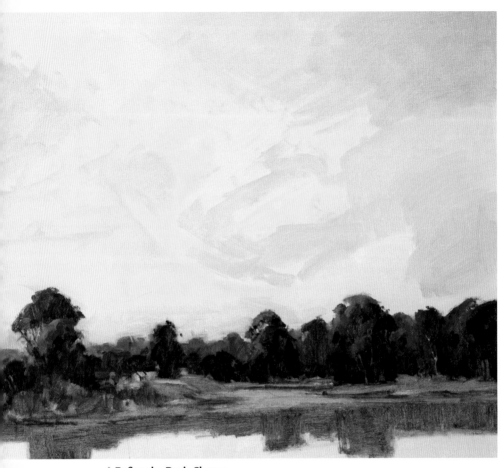

4 Refine the Basic Shapes

While the paint on the trees is still wet, add a mixture of Cobalt Blue, Titanium White and the lightest premixed gray at the base of the sky behind the trees on the left. Blend the edges of the sky and the trees with a clean filbert to create a soft edge. Wipe back the wet paint where you want to establish the buildings with a lint-free rag. Use a small brush to draw the buildings' structure. Establish a few trunks in the trees with a medium value of the premixed gray and a small brush.

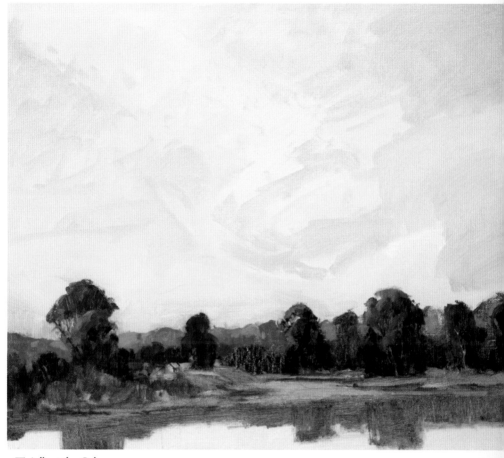

5 Adjust the Colors

Scrape back the trees with your palette knife if they look too gray. Now you can paint back into them with a little lighter value of the colors you used in step 3. Use a mixture of Cobalt Blue, Titanium White and a small amount of the premixed gray and lay down the new paint over the scraped areas. Mix a middle-value cool gray with Cobalt Blue, Titanium White and Chromatic Black for the background trees on the right, and add Viridian and Transparent Yellow Oxide to the middle-value gray for the trees on the left. This time use more pure color in the gray mixtures to bring back each gray's color identity.

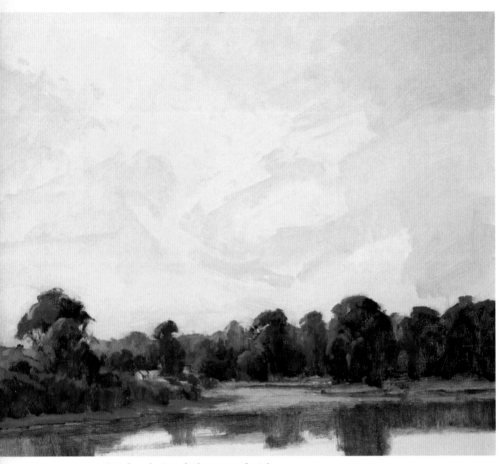

6 Refine the Land Closest to the Viewer
Here you'll focus on the trees on the left side. Simplify the shape of the trees and shrubs on the left side with a mixture of Sap Green, Ultramarine Blue and a touch of Transparent Red Oxide. Build up the trees using warmer and cooler versions of this green.

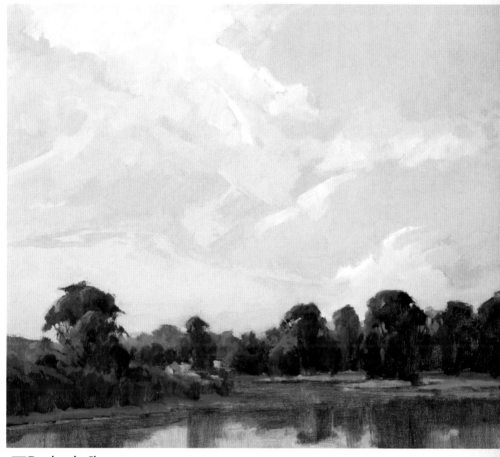

7 Develop the Sky

Now it is time to build the shapes and the complexity of the sky from the movement that was established at the start. For the base color, use Ultramarine Blue muted with Chromatic Black and Titanium White; apply this around the cloud shapes. While this is wet, lay in the lightest clouds with a mixture of Titanium White, Cadmium Orange and a touch of Cadmium Yellow Deep. Then select the appropriate value of your premixed grays to transition into the shadow areas of the clouds. To make the gray more colorful, add a touch of the pure hue to the gray to give it a color identity. Add a muted, middle value of gray to a tint of Cadmium Red Light and try it on a building's roof to see if this color will harmonize with the painting as a whole.

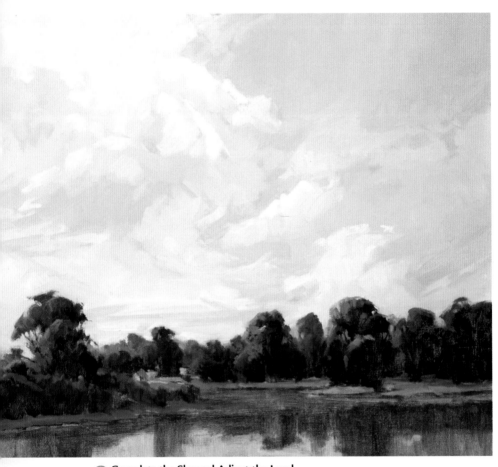

8 Complete the Sky and Adjust the Land

Refine the sky as necessary with the mixtures from step 7. Once you have established a nice balance in the sky, go back and refine the land. Lay in lighter shapes on the trees, shrubs and ground using warm green mixtures of Transparent Yellow Oxide and Ultramarine Blue (with more yellow than blue) and Transparent Yellow Oxide and Cobalt Blue (with more yellow than blue). Adjust the greens lighter or darker as necessary.

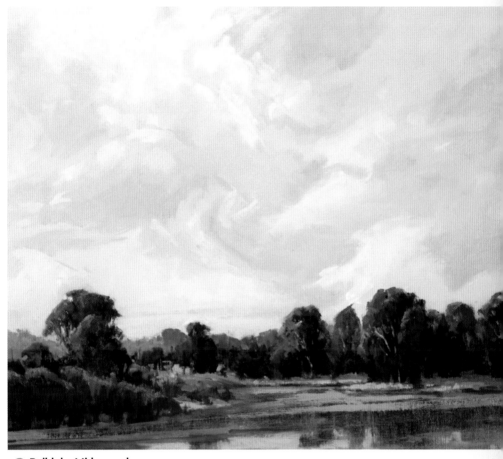

9 Build the Midground

Flesh out the trees and shrubs using the cool and warm variations of the green mixtures you have made on your palette. Paint the dark reflections in the water, then pull a blue darker than the sky over the reflections.

At this point I realized that the muted red on the building contrasted too much with this mostly green painting, so I wiped it off with a lint-free rag. Go back to the sky and soften the clouds' edges with a clean brush. Add a lighter blue gray layer of clouds in the upper right.

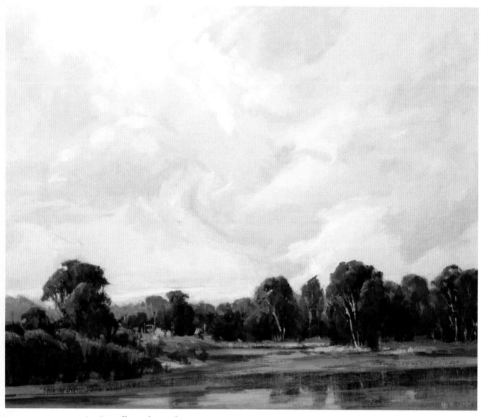

10 Adjust the Values

Where the light hits the land, apply a thick layer of Cadmium Yellow Deep, Titanium White and Transparent Yellow Oxide. This creates a nice contrast against the thinner, more transparent dark paint. Build up the forms of any trees that appear too skimpy, then refine their reflections. Darken or lighten areas that need adjusting and get rid of distracting warms or cools or mute a color that is too intense.

Paint the house back in with Cadmium Yellow Light, Transparent Yellow Oxide, Titanium White and a light value of the premixed gray using a small brush.

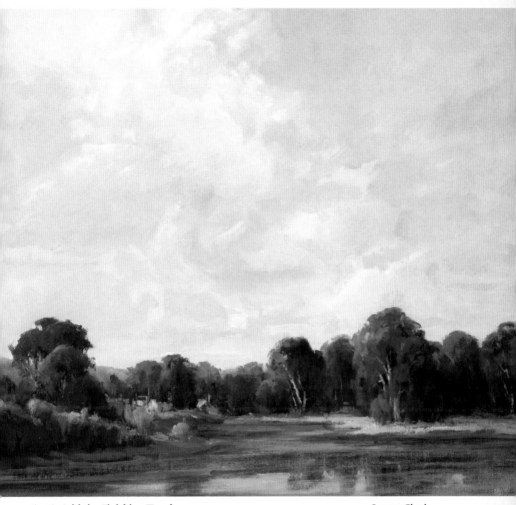

11 Add the Finishing Touches

Simplify and add contrast to the sky with more of the Ultramarine Blue and premixed gray from step 7. Paint around the dominant cloud shape.

Add warmth to the two trees that are the center of interest with a mixture of Cadmium Red Light, Cadmium Yellow Light and a little Viridian. Paint this lightly over the shapes already there. For variety, add a bit of grayed red to the far middle trees. Add a complementary reddish gray made of Ultramarine Blue, Cadmium Red Light and Titanium White along the shadow side of the land, adding more white as you move into the lighter areas. In the lightest area, add Cadmium Yellow Light to brighten the color and add warmth.

Add a glaze of Viridian and Transparent Yellow Oxide to the water to deepen the dark reflections. Add a shadow side to the building with Ultramarine Blue, Cadmium Orange, Titanium White and a touch of the bank's reddish gray. Add this color to the bank behind the house and between the two main trees.

Summer Clouds
Oil on linen on board
20" × 24" (51cm × 61cm)
Private collection

DEMONSTRATION
Subtle Color for a Foggy Morning

In this scene, the value range is narrow and the color intensity is low. Most of your edges will be soft. The light is cool, so you will learn to replicate cool light in your painting.

Use the brushes that are comfortable for you. It is always a good idea to start with larger brushes and use the smaller ones toward the end of the painting.

MATERIALS

OILS
Titanium-Zinc White, Cadmium Yellow Light, Raw Sienna, Transparent Red Oxide, Cadmium Red Light, Quinacridone Rose, Alizarin Permanent, Cobalt Blue, Viridian

MIXTURES
Warm light tint of Cadmium Red Light made with Titanium-Zinc White

Cool light tint of Cadmium Red Light and Cobalt Blue made with Titanium-Zinc White

Various values of a warm reddish gray made with Cadmium Red Light, Quinacridone Rose, Viridian and Titanium-Zinc White (Cadmium Red Light dominant)

Various values of a cool greenish gray made with Viridian, Cadmium Red Light, Quinacridone Rose and Titanium Zinc White (Viridian dominant)

SURFACE
Linen primed for oil

BRUSHES
Nos. 4, 6 and 8 hog-bristle flats; no. 4, 6 and 8 hog-bristle filberts; no. 2 script

OTHER
2 parts alkyd medium thinned with 1 part odorless mineral spirits, lint-free paper towels or rags, vine charcoal (for drawing)

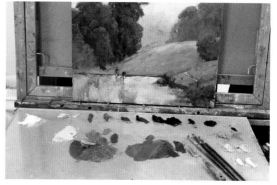

MY SETUP
Here you can see how I arranged my palette for this painting. The colors I will use are along the top, and on the far right I have the cool gray and next to that the warm gray. In the middle are the warm green and cool greens I will use.

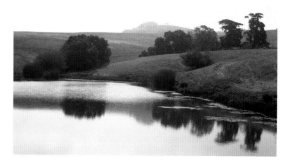

REFERENCE PHOTO

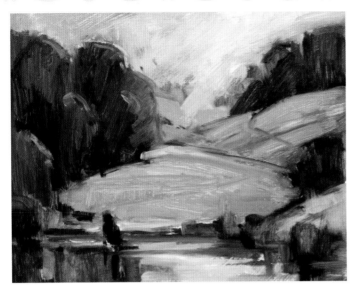

VALUE SKETCH

Create a value sketch from the color study to identify the value pattern. This could also be done with a pencil in your sketchbook.

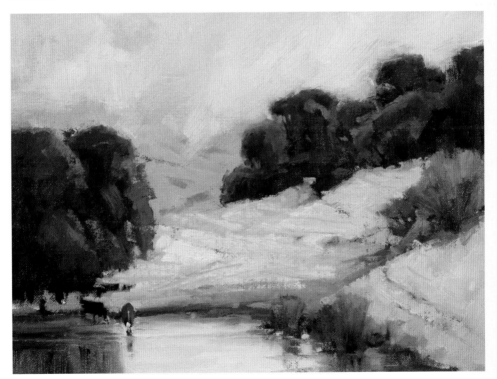

PLEIN AIR PAINTING

Morning Clearing
Oil on linen on board
10" × 12" (25cm × 30cm)
Collection of the artist

1 Block In the Design

On linen that has previously been given a thin transparent coat of Cadmium Red Light, sketch the composition with vine charcoal using the color study for a reference. With a paper towel or rag, lightly brush the charcoal off to leave a ghost image of the drawing.

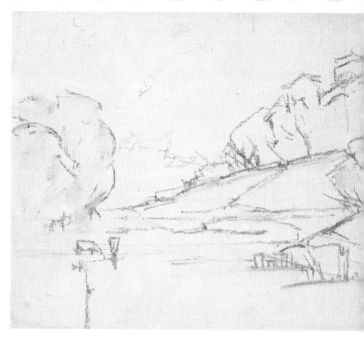

3 Establish the Land and Trees

While the paint is wet, use a rag to wipe back the red-orange areas of the trees, creating a stain that will add glowing warmth. Wipe back areas that will later be painted as the sky with the rag. Add Cadmium Yellow Light to the underpainting mixture of Viridian and Raw Sienna with a touch of Quinacridone Rose. Lay this semiopaque mixture on the tree tops and on the grasses in the water. Keep the paint transparent in the dark areas. Add a middle value of green-gray to the area behind the trees. Just lay this in—you will adjust it later. See how the temperature warms as each group of trees comes forward. With a small amount of Quinacridone Rose and Transparent Red Oxide, lay in a few transparent spots of color to represent the cattle.

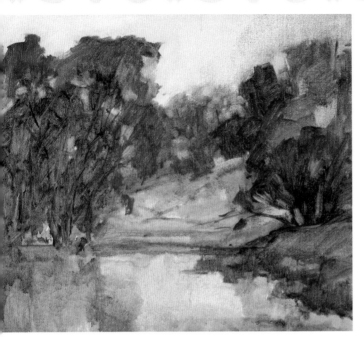

2 Lay in Transparent Shapes

Thin Viridian, Raw Sienna and Quinacridone Rose with the medium. Using different mixtures of these colors, create an underpainting of the large shapes with the no. 8 filbert. This layer will glow through the subsequent layers of paint.

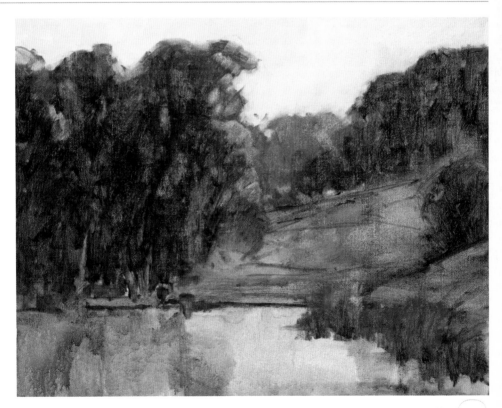

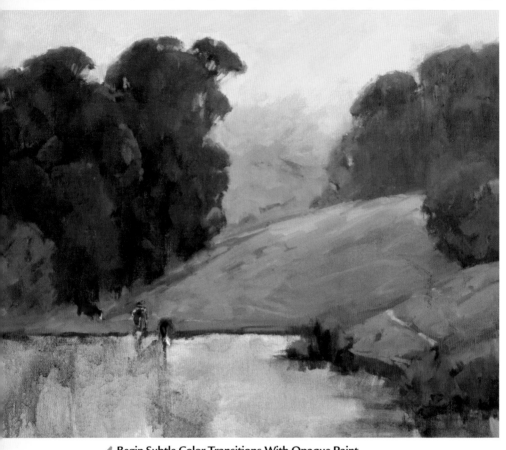

4 Begin Subtle Color Transitions With Opaque Paint

Mix Raw Sienna with the middle value of warm gray and apply this to the row of trees in the middle. Allow bits and pieces of the basecoat to show through this paint layer. Load a large, clean flat or filbert with a dark cool gray and lightly apply this to the distant trees. Add variety to the shape with other colors from your palette as needed.

With a large, clean flat, paint clouds around and behind the trees with a warm light tint of Cadmium Red Light and a cool light tint of Cadmium Red Light and Cobalt Blue. Pull the wet paint down over the distant hill. Work lightly to keep the wet paint from blending too much.

Keep things pretty simple now. Develop the trees as you move into the foreground. Build the trees with lighter values of the greens over the transparent paint. Create the basecoat on the rolling hills with a mixture of Raw Sienna and Titanium-Zinc White, using your warm and cool grays to adjust the intensity as needed.

Paint the cattle with a mixture of Alizarin Permanent and Viridian in the cool areas and a warm red mixture of Cadmium Red Light with a touch of Cadmium Yellow Light for the areas in sunlight.

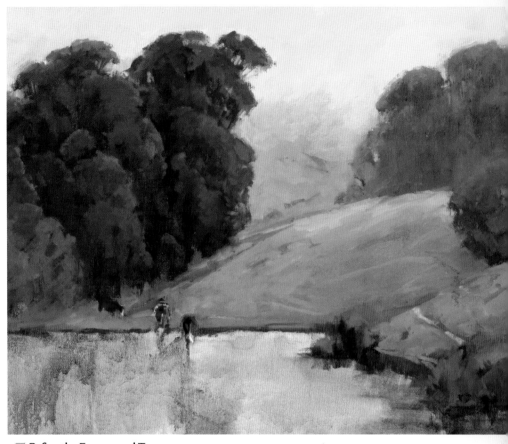

5 Refine the Foreground Trees

Continue to build volume in the trees with mixtures of Cadmium Yellow Light, Cadmium Red Light and Viridian. Vary the color by adding more yellow or red as you layer the paint. Use your largest flat or filbert to lay the paint on gently. Keep your marks loose, the shapes of the values connected and the lights cooler than the darks.

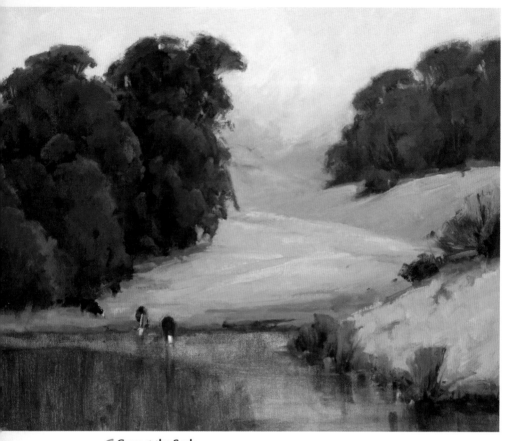

6 Correct the Scale

As the painting progresses, check to make sure the composition reads as well as you would like. Sometimes when a sketch is enlarged, the shapes that worked for a small scale don't look as good on a larger scale. Because the paint is thin, you can easily build new shapes over an existing shape. In this case, I decided to break down the large shape of the middle hill into two hills. Use a mixture of Raw Sienna and Titanium-Zinc White to create the smaller hill. If you need to lower the intensity of the mixture, add a touch of the light value warm or cool gray. The new layer should be warmer than the hill it overlaps.

Now that you have established the largest shape of trees, build the color and value of subordinate areas of the painting in relation to the main shape of the foreground trees. Pare down the shape of the hillside shrubs and grasses by painting more land around them. Since one change usually calls for another, apply vertical strokes to the grass along the water to build up this area. Apply a warm wash of Transparent Red Oxide over the water with a clean brush. Thinly paint a grayed green where the grasses' reflections will be.

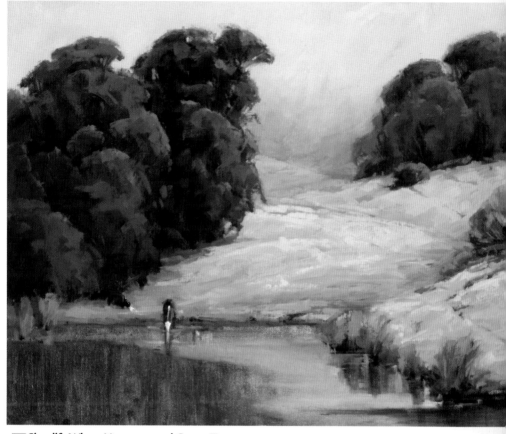

7 Simplify Where Necessary and Create Texture

Surrender one of the cow shapes by covering it as you build up the paint on the land. Such corrections are easy to make at this point because the paint is still transparent and easily painted over. Create a light tint of orange-yellow with Raw Sienna and Titanium-Zinc White and use this to paint the patterns of light on the middle and foreground hill with a medium-sized flat.

Use your medium-light cool gray to add light to the tops of the far trees. Do the same to the closer trees but warm up the mixture with Cadmium Yellow Light and a touch of Cadmium Red Light. Build up your grasses and foreground trees with the appropriate cool and warm greens. Create a cool violet with Titanium-Zinc White, Quinacridone Rose and the cool gray and lightly apply this behind the right tree shape. Add Titanium-Zinc White and the grayed-green mixture to create a light value that will represent the sky reflected in the water. Paint this passage thinly.

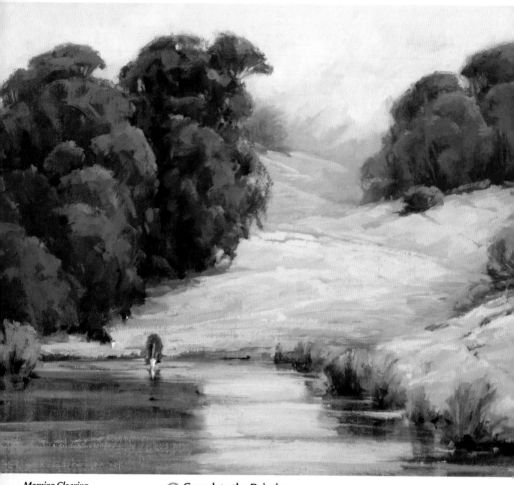

Morning Clearing
Oil on linen on board
16" × 20" (41cm × 51cm)
Collection of Bill & Sharon Smith

8 Complete the Painting

Over the cool gray reflections, refine the grasses' reflections by pulling some of the wet paint down into the water. If you don't have enough wet paint to pull from the grasses, apply some of the grasses' color from your palette to the canvas and vertically pull it into the water. Add a touch of dark cool gray with a touch of Viridian at the base of the grasses' reflections and pull those darks into the water vertically. Add more paint to the trees' reflections if they seem too thin with a light cool gray that relates to the trees. Paint the sky's reflection with a cooler, darker value. Use a light hand and a clean flat to pull the wet paint horizontally over the cool gray reflections. Try not to disturb the bottom layer of wet paint. Adjust anything that might be distracting to your eye and strengthen what you want to emphasize. Further develop the back hill to suggest trees covered in fog and to mute the colors. This will help draw the eye back to the center of interest.

Capturing Morning's Local Color

This studio painting demonstration will use many of the techniques we have discussed previously. The process will include painting transparently first, adding opaque paint and then glazing after the paint has set up.

In this demonstration, the painting will be developed from the local color of the landscape. Painters think of local color as the actual color of an object unaffected by atmospheric conditions or unusual lighting. The composition is a long format; the dominant color of the painting is green. The time of day is early and the sun is still pretty low in the sky.

The viewpoint is from the top of the bluff, looking down and across the valley.

MATERIALS

OILS

Titanium White, Cadmium Yellow Light, Cadmium Yellow Medium, Yellow Ochre, Transparent Yellow Oxide, Raw Sienna, Cadmium Orange, Permanent Red, Cadmium Red Medium, Transparent Red Oxide, Alizarin Permanent, Ultramarine Blue, Cobalt Blue, Viridian

MIXTURES

Warm black made with Permanent Red and Viridian

Warm gray made with Permanent Red, Viridian and Titanium White (Permanent Red dominant)

Cool gray made with Viridian, Permanent Red and Titanium White (Viridian dominant)

Cool green made with Ultramarine Blue, Transparent Yellow Oxide and a touch of Titanium White (Ultramarine Blue dominant)

Warm green made with Transparent Yellow Oxide, Ultramarine Blue and Titanium White (Transparent Yellow Oxide dominant)

SURFACE

Linen primed for oil and glued to a board

BRUSHES

Nos. 4, 6 and 8 hog-bristle flats; nos. 4, 6 and 8 hog-bristle filberts; no. 2 bright

OTHER

2 parts alkyd medium to 1 part odorless mineral spirits, lint-free rags

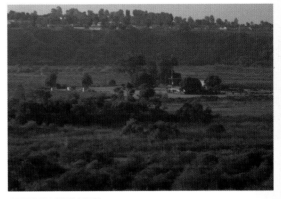

REFERENCE PHOTO
Here the morning light is soft and the air has moisture from the early morning fog that is starting to lift.

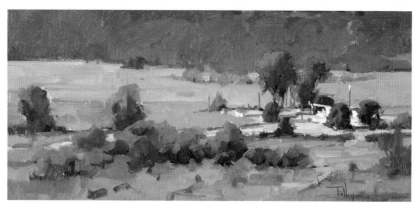

COLOR STUDY

Morning on the San Mateo
Oil on linen on board
8" × 16" (20cm × 41cm)
Collection of Michael Obermeyer

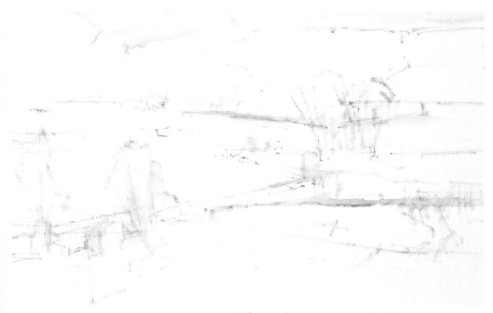

1 **Change the Format From the Field Study**
Create a larger foreground to give the viewer more room to move into the painting by shortening the long horizontal format. Use Cobalt Blue and Cadmium Red Medium to sketch out the composition.

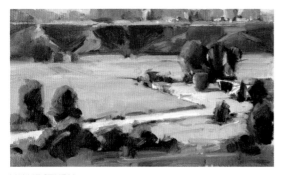

VALUE STUDY

To save time when you have already done a color study, you can take a digital photo of your sketch and desaturate the color electronically to see how the values are working.

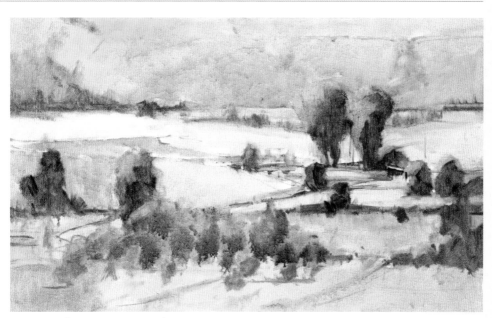

2 Lay In the Transparent Washes

With the no. 8 filbert, lay in transparent washes of Transparent Red Oxide, Transparent Yellow Oxide and Cobalt Blue. Consider the warm and cool, light and dark areas of the painting as you lay the first layer of thin paint, but give yourself room for change. As paintings become larger, some areas may need more information.

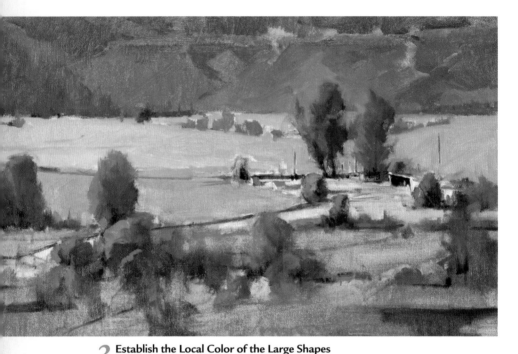

3 Establish the Local Color of the Large Shapes

As the painting is proceeding, establish the landscape's local color. Paint the distant bluff and trees with a transparent layer of Viridian and Ultramarine Blue. Over that, apply a mixture of Quinacridone Rose and the middle-value green-gray on the side of the bluff. If this is too light, add some Viridian or Ultramarine Blue. Start to build the greens in the trees and shrubs with the medium value of red-green and the cool dark green mixtures. If they are too dark, lighten with the green-gray or with one of your yellows. Add some middle-value green-gray to the shrubs where you would like lighter values.

Paint the foreground with a thin layer of Transparent Yellow Oxide and Cobalt Blue. As you move toward the background add more Cobalt Blue and some Titanium White to the mixture, but keep the application thin. For the warm light area, use a touch of Transparent Red Oxide mixed with Titanium White. Use a lint-free rag to wipe out a big shape in the foreground, removing any excess paint and leaving the canvas with a warm gold-green layer.

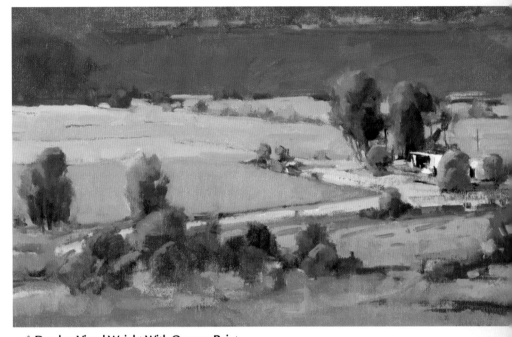

4 Develop Visual Weight With Opaque Paint

Paint the bluff's walls thinly with a middle value of Cobalt Blue, Permanent Red, Viridian and Titanium White. Working from the distance and moving toward the foreground build up the shrubs, trees and foreground trees with a variety of greens, painting the shadow sides cooler and darker than the light sides. Add a bit of pure color to the green mixtures to vary the colors in the landscape. Add Cadmium Yellow Medium for warm greens where necessary because it does the best job of warming up the greens.

Refine the foreground with a mixture of Raw Sienna, Permanent Red and Cobalt Blue. If necessary warm the mixture with a touch of Yellow Ochre. Use a mixture of Cadmium Yellow Medium, Cobalt Blue, Yellow Ochre and Titanium White for the cultivated fields, using a light hand as you apply the paint. Mix Cadmium Orange, Raw Sienna, and Titanium White and lay this down for the road. Make a violet with Cobalt Blue, Permanent Red, Viridian and Titanium White and add it to the shadows on the ground plane.

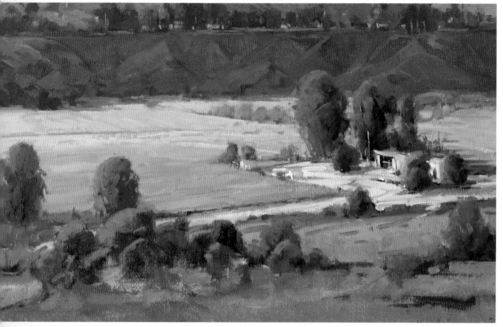

5 Build the Forms and Color

Create the form of the bluffs with the largest brush you are comfortable using and a lighter value of the Cobalt Blue, Permanent Red, Viridian and Titanium White mixture. Follow the contours of the bluffs with your brush. Use your warm and cool grays to adjust the color as necessary. Use the cool gray with the cool green to suggest dark green trees in the distance. Add some pure hue to the trees for variety. Create the illusion of distance by painting around the trees with lighter warm and cool grays. Add a couple of light gray dashes to suggest the homes. Move on to the midground.

Build volume in the trees on the flat plane with more layers of the greens from step 4. As you build the mid ground trees with thicker paint, cover most of the bright yellow, letting the trees recede more. As the trees turn from the light, add Cadmium Orange. Paint the buildings with thicker paint from steps 3 and 4. Keep the shadow sides cooler and thinner than the sunlit sides. Build up the paint in the fields; keep your greens the same value, but change the hue and temperature as needed with appropriate colors from your palette. Add a blue gray shadow of Ultramarine Blue, warm gray and warm green on the grass at the base of the bluff. To the road, add a middle value of warm gray. Add a lighter value of warm gray to the road, leaving the darker value showing through.

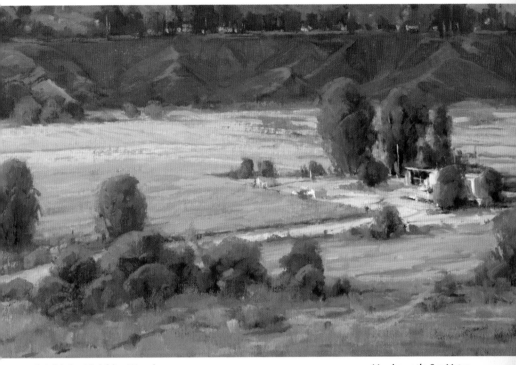

6 Add the Finishing Touches

At this stage of the painting the forms are more apparent because of the build up of warm and cool, dark and light paint. The darkest darks and lightest lights are in the midground around the trees and the farm buildings. Add color notes of orange and red and a warm, intense green tint to the farm buildings for variety and interest. Paint the sunlight on the bluffs with a middle value of warm gray and some Cadmium Orange or Raw Sienna.

With a clean filbert, build the texture of the grasses in the foreground and add some dark diagonals with a middle value of cool gray. Build the bushes with the greens used for the trees, keeping your brushwork loose and dragging the loaded brush over the wet paint. This creates an interesting texture while allowing the color underneath to show through. Add texture to the fields by building them up with more Cadmium Yellow Light. Simplify the painting where necessary. Let the bottom layer of paint show through in areas to create the broken color and the texture.

Morning on the San Mateo
Oil on linen on board
12" × 20" (30cm × 51cm)
Collection of the artist

DEMONSTRATION
Focusing on Color and Light

In this demonstration you will work with warm, vibrant spring colors to create a painting that represents mid-morning light. The focus is more on colors and color relationships than value. The painting is designed with the largest tree as the focal point, but the composition allows the viewer's eye to move around the painting.

MATERIALS

OILS
Cadmium Yellow Light, Cadmium Yellow Deep, Transparent Yellow Oxide, Cadmium Orange, Cadmium Red Medium, Quinacridone Rose, Transparent Red Oxide, Ultramarine Blue, Cobalt Blue, Viridian, Titanium White

MIXTURES
Cool blue-gray made with Ultramarine Blue, Cadmium Orange and Titanium White at a value 6 or 8.

Greenish gray made with Viridian, Cadmium Red Medium, a touch of Quinacridone Rose and Titanium White

SURFACE
Linen primed for oil and glued to a board

BRUSHES
Nos. 2, 4, 6 and 8 hog-bristle flats; nos. 2, 4, 6 and 8 hog-bristle filberts; no. 2 bright

OTHER
2 parts alkyd medium and 1 part odorless mineral spirits, lint-free rag, vine charcoal (for drawing)

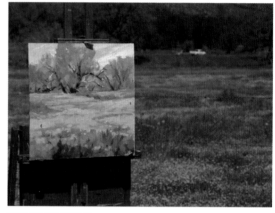

LOCATION SETUP

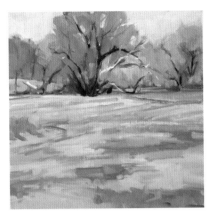

VALUE STUDY

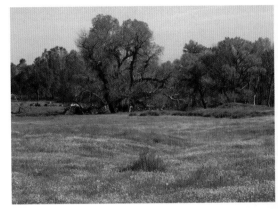

REFERENCE PHOTO

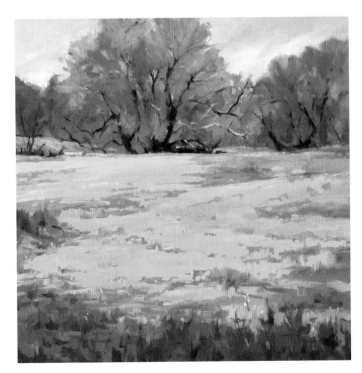

COLOR STUDY

Color Study: Spring on Shell Creek
Oil on linen on board
12" × 12" (30cm × 30cm)
Collection of the artist

1 Establish the Big Shapes

Using Transparent Yellow Oxide, Quinacridone Rose, Cobalt Blue and Viridian thinned with medium (here you can how the paint runs down the canvas with too much OMS), paint in the large shapes blending the colors on the canvas to with your largest filbert or flat. Let this dry.

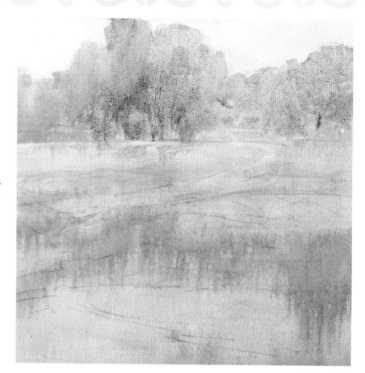

2 Sketch Details Over the Underpainting

Use vine charcoal to lightly draw the tree trunks and to indicate the action lines. If you are not happy with anything in your initial sketch, wipe it away with a lint-free rag and resketch.

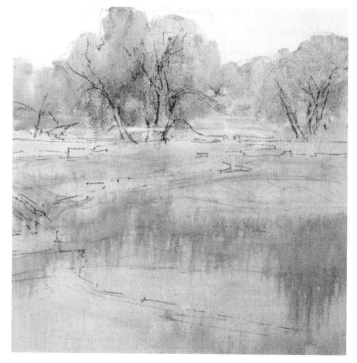

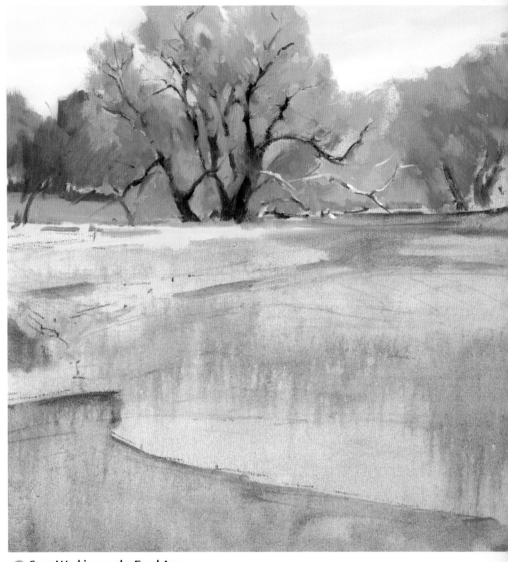

3 Start Working on the Focal Area

With a brush that's comfortable to draw with, develop the trunks with a thin, transparent mixture of Transparent Red Oxide and Cobalt Blue. With Cadmium Yellow Light, Transparent Yellow Oxide, Cobalt Blue and Quinacridone Rose and Titanium White paint the light and shadows in the trees with a no. 8 filbert or flat. Use the green grays or blue grays to modulate your colors as needed. Lay in a light at the base of the large tree with Cadmium Yellow Light. Lay in darker transparent shapes in the foreground with Transparent Yellow Oxide and Quinacridone Rose. These are markers to remind you of the movement and shapes you will paint later. Keep your paint thin at this point.

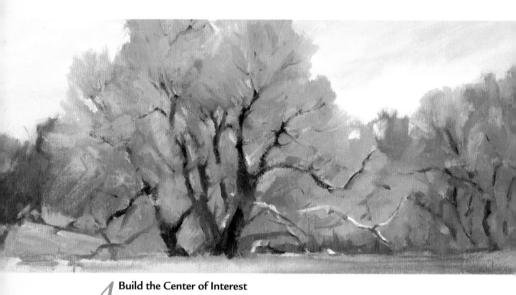

4 Build the Center of Interest

Develop the upper third of the painting. First flesh out the tree by adding Cadmium Yellow Light and Titanium White to the Transparent Yellow Oxide and Cobalt Blue mixture from step 3. Make it warmer or cooler, richer or grayer as necessary. Create a cool muted blue violet for the area behind the base of the trees with a mixture of Viridian, Quinacridone Red and Titanium White with a touch of Cobalt Blue. Mute this mixture with the premixed green gray as you work on the background trees. Thinly paint the sky with a blue made with Ultramarine Blue, Viridian and a tint of Cadmium Orange.

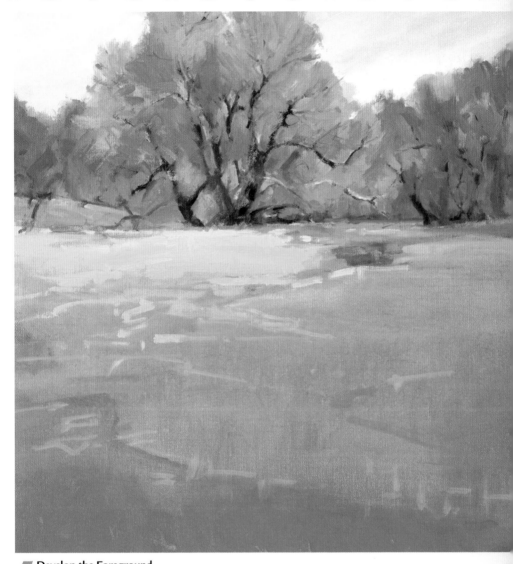

5 Develop the Foreground

The foreground is designed to move the viewer's eye toward the center of interest (the trees), so its color should be harmonious with the rest of the composition, yet have a bit of variety. Starting near the center of interest, paint a medium value of light green made with Cobalt Blue and Cadmium Yellow Light just darker than the yellow near it. Add a bit of Quinacridone Rose and Titanium White to the blue-gray and use this to create the violet patches. Lay the paint down with a clean flat and do not blend. Create yellow marks that establish the composition's movement with Cadmium Yellow Deep, Transparent Yellow Oxide and Titanium White. Keep the value dark, so that you will have room to build lighter, brighter color.

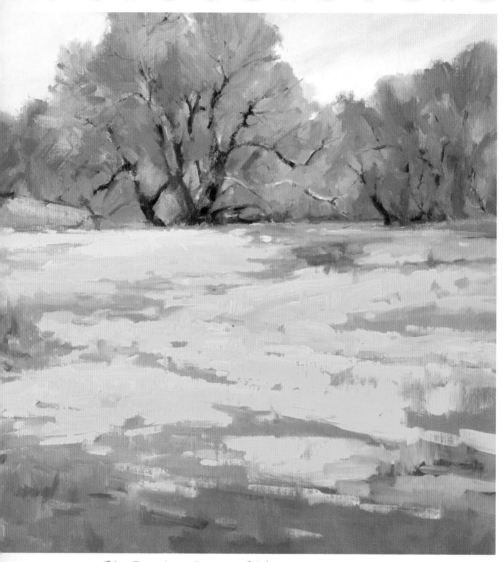

6 Lay Down Large Passages of Color

Paint large passages of color in the foreground with your yellows, starting with Cadmium Yellow Light under the trees and moving to warmer yellows such as Cadmium Yellow Deep as you work forward. Save the brushes that you are using for your yellows only for the yellows, or make sure you clean them well before changing colors. Create oranges and warm violets by mixing the yellows with Quinacridone Rose and Cobalt Blue; intersperse these colors within the yellow field. Keep the color subtle. Make greens with Cobalt Blue, Viridian, Transparent Yellow Oxide and the grayed greens on the palette. Vary your brushwork and keep the strokes loose. Use vertical strokes for the some of the foreground grasses, but keep these to a minimum.

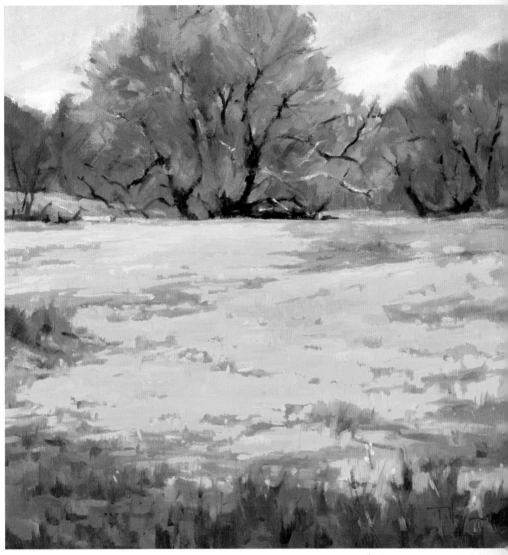

7 Add Detail to the Foreground and Refine the Painting

Use a small filbert to define the grasses with darker and lighter values. Create texture in the field of flowers with vertical strokes using the yellows from step 6. Now add more dark and light branches to the trees, adding Titanium White to the lightest areas in the branches and in the field the paint is wet and the white will loose some of its intensity.

Spring on Shell Creek
Oil on linen on board
16" × 16" (41cm × 41cm)
Collection of the artist

Painting En Plein Air

This demonstration will address painting alla prima *or wet into wet. To be able to complete the painting outside in one session, keep the composition simple and the size rather small.*

MATERIALS

OILS

Cadmium Yellow Light, Cadmium Yellow Deep, Transparent Yellow Oxide, Cadmium Orange, Raw Sienna, Cadmium Red Light, Transparent Red Oxide, Quinacridone Rose, Ultramarine Blue, Cobalt Blue, Viridian, Titanium White

MIXTURES

Grays made with Viridian, Cadmium Red Light, Quinacridone Rose and Titanium White in a range of values

Tints made with: Cadmium Yellow Light and Titanium White; Cadmium Yellow Deep and Titanium White; Cadmium Orange and Titanium White; Cadmium Red Light and Titanium White

SURFACE

Linen primed for oil

BRUSHES

Nos. 2, 4, 6 and 8 hog-bristle flats; nos. 2, 4, 6 and 8 hog-bristle filberts

OTHER

1 part alkyd medium to 2 parts odorless mineral spirits, paper towels, rubber gloves

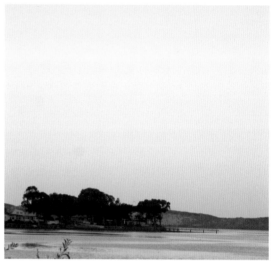

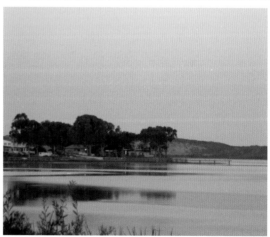

REFERENCE PHOTOS

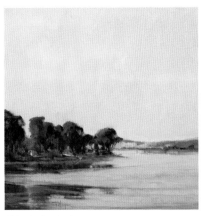

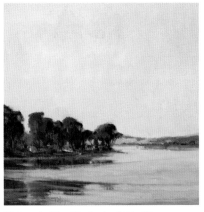

Plein air color sketch

Photograph of the plein air color sketch with desaturated color

GETTING THE COLOR RIGHT OUTDOORS AND IN

Since the colors of daybreak don't last long, it's more important to create a strong visual memory of the color than to spend time on a value study. So, do a color study *en plein air,* then take a digital photograph of the study and desaturate the color on your computer to check or evaluate the value patterns.

Daybreak
Oil on linen on board
16" × 16" (41cm × 41cm)
Collection of Arthur Ermish

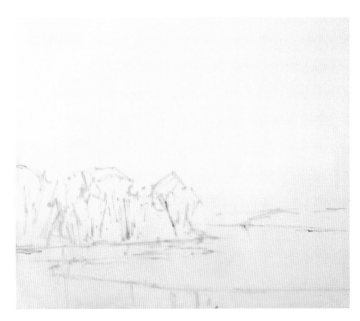

1 **Prepare the Canvas**
Stain the canvas with Cadmium Yellow Deep and Cadmium Orange. With a clean paper towel dipped into the paint, rub the paint into the canvas. (Remember to protect your skin with rubber gloves.)

Draw in the large shapes with a small bristle brush and a mixture of Cobalt Blue and Cadmium Red Light while the canvas is still wet.

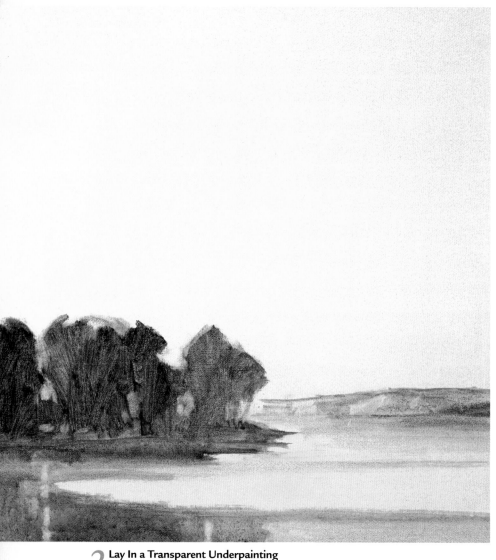

2 Lay In a Transparent Underpainting

With your largest filbert or flat, lay in the large shapes of the trees, land and water reflections with Transparent Yellow Oxide, Cobalt Blue, Quinacridone Rose and Viridian and alkyd medium thinned with OMS. Mix these colors together to create a warm, neutral tone. With the same brush, add Ultramarine Blue to darken the shadow sides of the trees. Add Transparent Red Oxide along the banks of the land.

With a clean brush, use Quinacridone Rose, Cobalt Blue, Viridian and a touch of Transparent Yellow Oxide to lay in the dune's shapes. Use a paper towel to lift out the paint in the lighter areas in the water and trees.

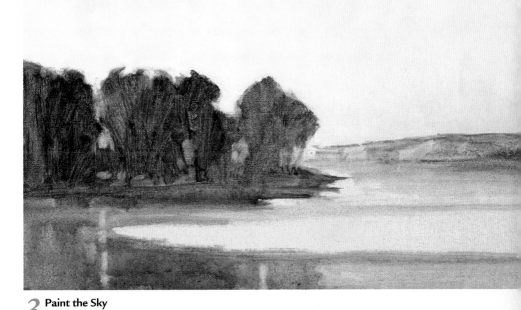

3 Paint the Sky

Paint the sky, establishing the light and color that will be reflected in the water and to define your lightest area. With the no. 8 flat or filbert, start above the dunes and move upward with a mixture of Cobalt Blue and a light tint of Cadmium Red Light (a value of about 7 or 8). Decide where your warmest area should be and work toward that point from the coolest area as you move up the canvas. In this case, the warmest area is the Cadmium Deep tint on the left, which you will work up to from the cool blue-violet in the bottom right corner of the sky. Use your premixed tints to make gradual color and temperature changes. As you change temperature and color, remember to either clean your brush or change brushes.

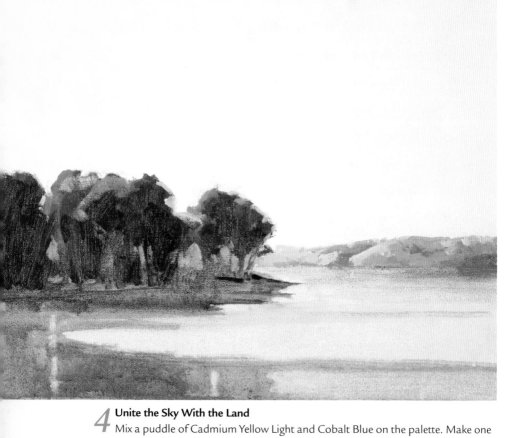

4 Unite the Sky With the Land

Mix a puddle of Cadmium Yellow Light and Cobalt Blue on the palette. Make one side of the puddle mainly blue and the other side mainly yellow. Lay the mostly yellow mixture on the tops of the trees where the sun hits. Use the cooler, bluer mixture on the area of the treetops in shadow. (These will be blended with the sky later.) If the color seems too intense, mute it with a premixed gray of the same value. Lay in a cool, middle-value gray behind the trees.

Paint the dunes with a mixture of Raw Sienna and Titanium White for the light areas, and Raw Sienna, Cobalt Blue and Quinacridone Rose for the cool areas, using a small, clean flat or filbert. Soften the tops of the dunes with any clean brush.

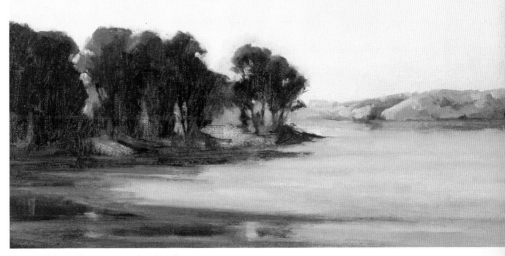

5 Build Up the Trees and Paint the Water

Build up the trees with more of the Cadmium Yellow Light and Cobalt Blue mixture with a little dark gray added to create a slightly opaque mixture. Vertically pull some of this down over the water to create the trees' dark reflections. Lighten as necessary with the premixed grays. In the lighter areas of the water, use the tints from the sky, but darken them with a darker premixed gray or cool them with a touch of Cobalt Blue. If you gray them too much, add some pure hue back into the mixture. Keep the paint thin as you lay down your first layer. With the cool blue gray lay in some horizontal strokes of thin paint over the dark tree reflections, representing the patters of the water current.

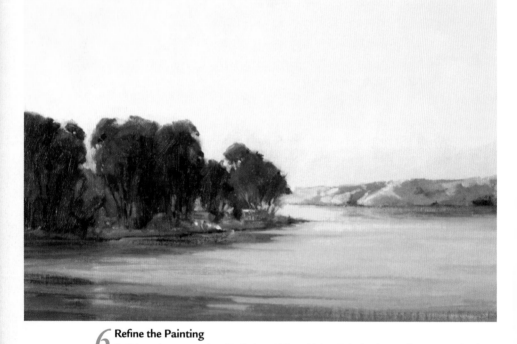

6 Refine the Painting

Build up the trees using Cadmium Yellow Light, Cobalt Blue and your premixed grays with a clean filbert. Shape and soften edges where needed. Create the illusion of trunks with your smaller filbert. Paint around those shapes to integrate them into the painting. Paint the land with Raw Sienna, Cobalt Blue and Titanium White. Keep the color subtle and the value low enough so the land and trees stay connected as a large shape. Create houses with a dash of Viridian and Titanium White. Where the sun hits the houses, add Cadmium Yellow Light. Put a bit of the houses' color into the reflection. Add a muted red made of Cadmium Red Light, Viridian and Raw Sienna to the roof and a cool red made of Quinacridone Rose and a light premixed gray to the shore.

Build up the dunes with a medium-size flat. Add a mixture of Quinacridone Rose, Cobalt Blue, Raw Sienna and Titanium White to the shadow side of the dunes. Add some of this violet mixture to the reflections. Refine the water using more of the mixture from step 5. The water should be cooler than the sky. The paint should be wet and move easily. Soften edges in the painting as needed with a clean brush.

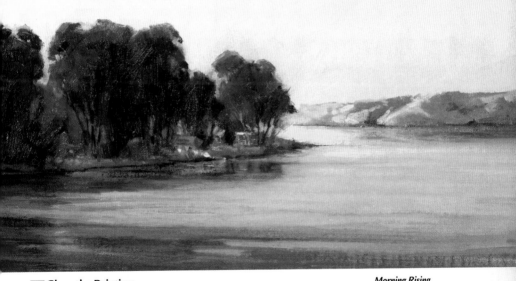

7 Glaze the Painting

Once the painting is dry to the touch, glaze some areas to darken their value. I did this to the trees with a glaze of Cobalt Blue and a touch of Transparent Yellow Oxide. Add a touch of a darker value of the houses' greenish blue to the water, suggesting their reflections.

Morning Rising
Oil on linen
16" × 16" (41cm × 41cm)
Collection of the artist

217

Conclusion

"Is the painting finished?"

The only person who can answer this question is you. Try to stop painting before you think you are completely done and let the painting rest. With a fresh mind, ask yourself: *Did I accomplish my goal? What do I like about this painting? What would I change?* These are simple, direct questions that will help you critique your work in a positive manner. Doing this encourages you to evaluate your own work and take personal responsibility for it. After you have identified what it is that you like, you can consider what you would have done differently or what you could still do that would enhance your painting. Get together with a fellow artist who understands your goals as a landscape painter. Work on critiquing together. Learn to give and take constructive criticism and use what you think will work. Think of critiquing as another tool in your paint box, and learn how to use it.

Use this book. Set it next to your palette, get paint on it, and make notes in it. Practice the exercises and explore the techniques. Try different formats. Take chances with the way you design. Get a grasp on how you want to paint, and what feels right for you. See if adding glazes, scumbling and drybrushing would enhance the way you work. Visit art museums and art galleries and consider what pieces you are attracted to. Get to know your colors and their personalities. The more you know about your materials and the more you use them, the more confidently you will apply the paint.

With all this knowledge, you will be able to focus on why you are painting and what you want to express. Remember, the *why* precedes the *how*. Try to translate the landscape to your own vision. Your voice will materialize on the canvas and your style will emerge.

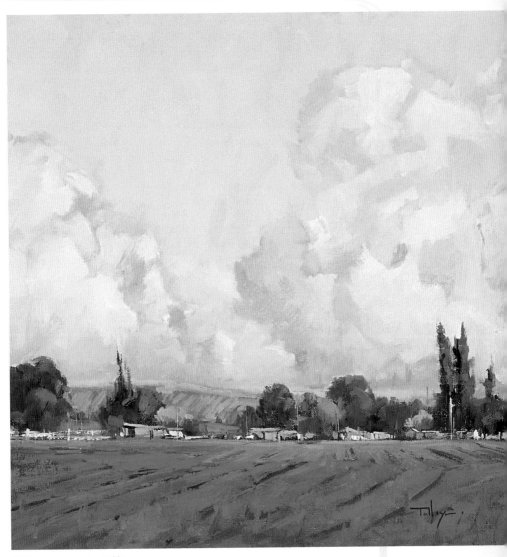

Winter Afternoon, Paso Robles
Oil on linen on board
16" × 16" (41cm × 41cm)
Collection of Alan Acosta & Tom Gratz

Index